DORSET

uck

yre

West Bexington

Abbotsbury

St Catherine's chapel

Swannery

Langton Herring

Fleet

Weymouth

Wyke Regis

Ferrybridge

Dorset
from the sea

The Jurassic Coast from Lyme Regis to Old Harry Rocks
photographed from its best viewpoint ... the sea

Steve Belasco
With a foreword by **Dame Ellen MacArthur**

www.veloce.co.uk

For post publication news, updates and amendments relating to this book please visit www.veloce.co.uk/books/V4762

First published in February 2015 by Veloce Publishing Limited, Veloce House, Parkway Farm Business Park, Middle Farm Way, Poundbury, Dorchester DT1 3AR, England. Fax 01305 268864 / e-mail info@veloce.co.uk / web www.veloce.co.uk or www.velocebooks.com.

Throughout this book logos, model names and designations, etc, have been used for the purposes of identification, illustration and decoration. Such names are the property of the trademark holder as this is not an official publication. Readers with ideas for automotive books, or books on other transport or related hobby subjects, are invited to write to the editorial director of Veloce Publishing at the above address. British Library Cataloguing in Publication Data – A catalogue record for this book is available from the British Library.

Typesetting, design and page make-up all by Veloce Publishing Ltd on Apple Mac. Printed in India by Replika Press.

Dorset
from the sea

The Jurassic Coast from Lyme Regis to Old Harry Rocks
photographed from its best viewpoint

Steve Belasco

With a foreword by Dame Ellen MacArthur

Contents

Foreword by Ellen MacArthur

I have wonderful memories of my first view of the Dorset coast. I was 19 years old, and more than half way through my first solo journey.

The challenge I had set myself was to sail around Great Britain alone, which was the most wonderful adventure in its own right.

From my tiny boat, Iduna, I saw some magnificent views of the UK coastline, but one of the most striking was my first landfall of the Dorset coast: Portland Bill.

Renowned for wrecking boats, the island's steep cliffs rose above me, and were as immense as the currents that were swirling us about as it lived up to its reputation.

Following my rounding of 'The Bill' came a stay in the delightful port of Weymouth, where I was made to feel extremely welcome, a large part of which was due to the kindness shown to me by the author of this book, Steve Belasco.

We met when he was working for the local newspaper and he'd been sent to photograph this crazy young girl.

Steve was kind enough not only to show me round the beautiful county of Dorset – and buy me fish and chips more than once – but also to venture out and take some pictures of me sailing Iduna off the coast: silly as it may seem, solo sailors usually suffer a shortage of pictures of themselves at sea!

So, this foreword not only brings back memories of the kindness shown to me by strangers so many years ago, but also happy memories of Dorset's wonderful coastline ... thanks, Steve.

A young Ellen MacArthur sails her yacht, Iduna, past Nothe Fort in Weymouth Bay. (Author photo)

*Courtesy Th Martinez/
Sea & Co*

Author's introduction

One man and his boat ... and his camera

When I first arrived in Dorset as a humble local newspaper photographer I was stunned by the scenery. A quarter of a century on, I still am.

My erstwhile interest in sailing was immediately rekindled by the blue water and micro-climate that Dorset enjoys. To illustrate the latter, a few years ago, when England was under the heaviest snow for decades, I saw an amazing colour photograph in one of the broadsheet newspapers. It was a satellite image of our country totally covered in a blanket of white. Totally, that is, apart from a tiny green speck on the south coast, which was, of course, Dorset.

I've been pottering up and down our Jurassic Coast for many years now, always marvelling at the wonderful views, but, perhaps, taking it all a little too much for granted. Four years ago, however, I suddenly twigged that I could combine three of my passions – boats, photography, and my adopted home county – to create a library of photographs taken from Dorset's best viewpoint ... offshore.

I'm keen to make as many people as possible aware of the beauty and drama provided by this extraordinary coastline, which has given us our unique, 'tilted' geology, abundant wildlife, a host of legendary smugglers and blaggards, and even the TV location for the Daleks' home planet 'Skaro.' Not to mention World Heritage status.

There's also a plethora of colourful and varied maritime activity; be it commerce or pleasure, and there's always someone doing something in our coastal waters, in all seasons, and throughout the day.

I've been developing an image library at www.jurassicphotographic. com where anyone can get a close-up look at my wonderful home turf (or should that be surf?).

I've tried to capture the Jurassic Coast and its surroundings in most moods and weathers, spending as much time as possible on the water; all the while balancing family life and a full-time job.

Many of the stretches of this coastline have no refuge if it gets a bit rough or the engine misbehaves, and dense fog banks – when you can't see anything, least of all the coast – can form alarmingly quickly, particularly in early summer. Spectacular sunsets have often held my attention far longer than intended, resulting in the return of Strange Weather to her mooring well after dark. Occasionally, I've spent too long squinting through the camera viewfinder and not noticed that the boat has drifted uncomfortably close to the rocks – you really need four hands: two for the boat and two for the photography.

Thanks

I must thank my long-suffering spouse, Josie, my loyal but sternest critic (otherwise she may hide the boat keys again), and the patience of my sons, Louis and Tristan.

I must also acknowledge Dr Ian West, Stuart Morris, Peter Bruce, Gordon le Pard, and the late Rodney Legg, for unknowingly helping me to create this book. Without their vast knowledge of all things Jurassic Coast – geological, geographical, social and navigational – this wouldn't have been possible.

On this photographic journey I've tried to be as honest as possible. These images have had nothing removed or added by computer, and sometimes this has meant leaving in the undesirable evidence of human thoughtlessness, not to mention the ubiquitous scaffolding.

In the digital darkroom I may have emphasised what I see in terms of colour and contrast, but my mission is to show Dorset's coast as it really looks, 'warts and all.' It may not be quite as it was 190 million years ago in the Lower Jurassic period, but it's still pretty damn good!

Whether you're local or a visitor, I do hope you're as astounded as I repeatedly am by the varied splendour of Dorset's World Heritage coastline ... viewed from the sea.

A proportion of the proceeds from this book will go to the Ellen MacArthur Foundation Trust.

I was lucky enough to get to know a teenage Ellen during her extended stay in Dorset, while storms raged in the Channel.

These delayed her single-handed journey around Great Britain in her diminutive yacht, Iduna, which was eventually to earn her the Young Sailor of the Year award for 1995.

But while here she used her time to see and enjoy as much of Dorset as she could, and I well remember her saying that she'd never forget her first sight of Portland Bill.

Now, having repeated her remarkable feat on a global scale, and so much more, Ellen spends much of her time helping young people recover their self-confidence after the ravages of cancer. By buying this book, you're helping them, too. Thank you.

VISIT VELOCE ON THE WEB – WWW.VELOCE.CO.UK
All current books • New book news • Special offers • Gift vouchers • Forum

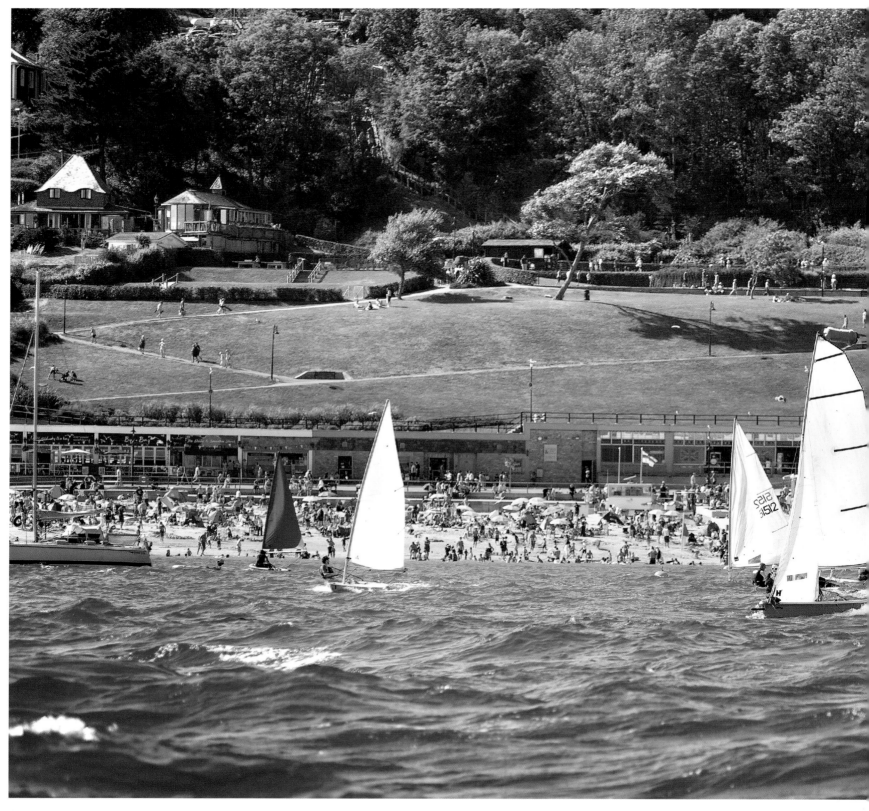

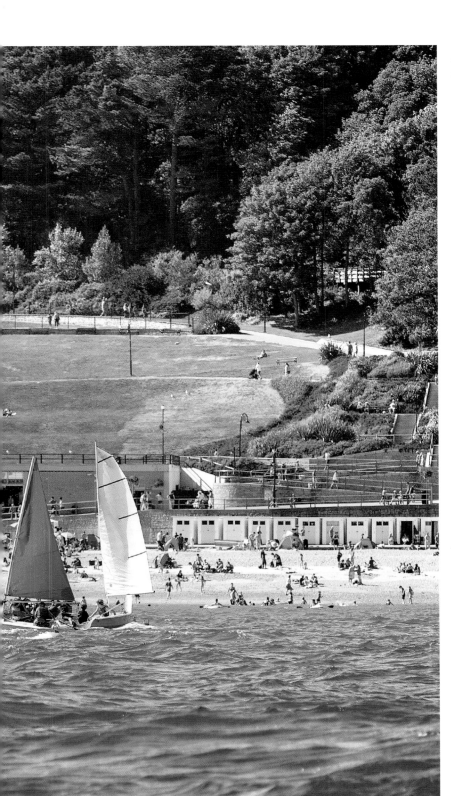

Langmoor Gardens form a verdant backdrop to busy Lyme Regis beach as we head out of the harbour and into Lyme Bay.

Lyme Bay

Lyme Bay is more than 40 miles across. Thomas Hardy called it Deadmans Bay in his novels, on account of the huge number of ships and lives it has claimed over the centuries. In the days of sail, boats and ships were often driven in by the prevailing sou'westerlies, and those aboard soon found that there was no way out in a storm.

The majestic cliffs of the far west gradually give way to the 18 miles of shingle which forms the famous Chesil Beach. Nowadays, this part of Lyme Bay is often bypassed by mariners, and is considered by some misguided souls to be a little austere and barren. This is a shame, really, because the serene, minimalist beauty of Chesil has a character all of its own; changing colour with the time of day, from dazzling white to a deep ochre, and accompanied by the constant rumble of the swell, sucking and re-distributing the mellow-toned pebbles; all set against the verdant backdrop of the fertile West Dorset hills.

The barrier beach, comprised of an estimated 180 billion pebbles, was formed as sea levels rose rapidly after the last ice age, though there's still some debate over precisely how it developed.

I enjoy pottering along in my little boat, a couple of hundred metres offshore. Fishermen's brollies, and the strange sculptures of flotsam and floats provide splashes of vibrant colour. You can often hear the chattering of the colony of little terns that breed here, and the whole lot is presided over by vast, striking skies, which can only be truly appreciated from seaward.

Wildlife sightings are startling: a veritable marine menagerie! Hundreds of species are regularly recorded in Lyme Bay, from white-beaked dolphin to whales, and sunfish to storm petrels.

So, enjoy these first 22 miles of the Dorset coast, from its western tip at Lyme Regis to the south-eastern end of Chesil, at Chiswell on Portland.

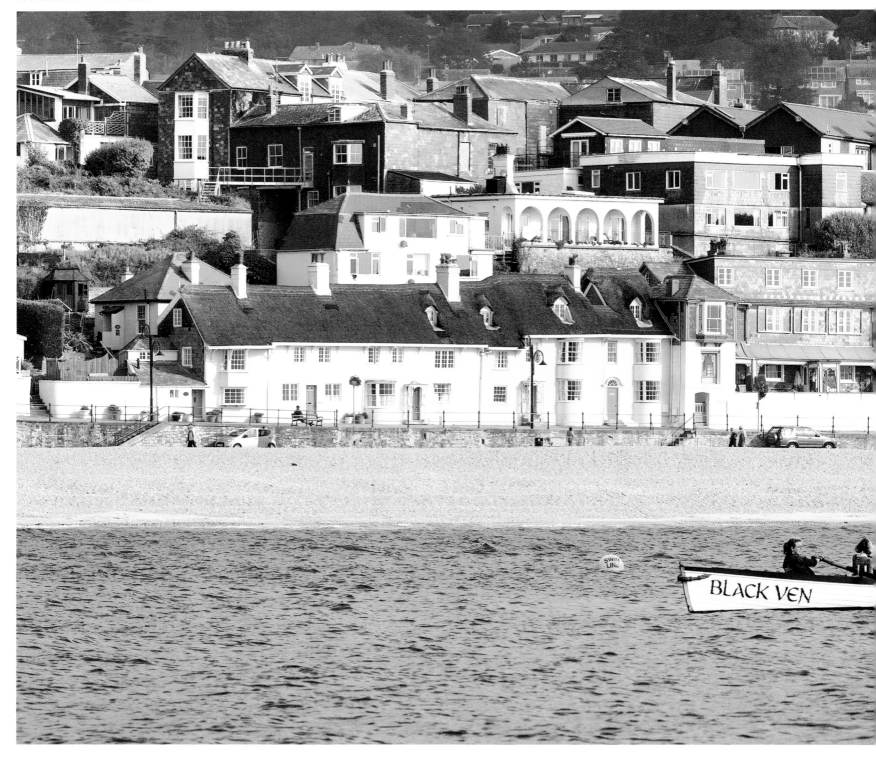

The crew of the Lyme Regis rowing gig Black Ven practise in front of the colourful town early on a Sunday morning. The boat is named after the nearby cliff, the site of the largest coastal mudslide in Europe, and the crews are made up of both sexes and all ages.

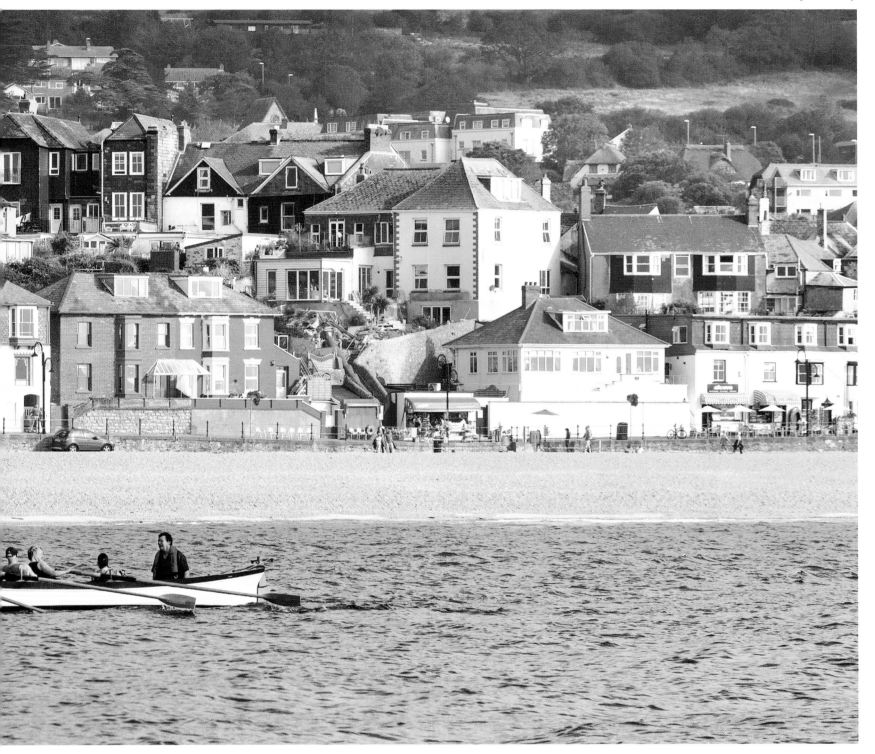

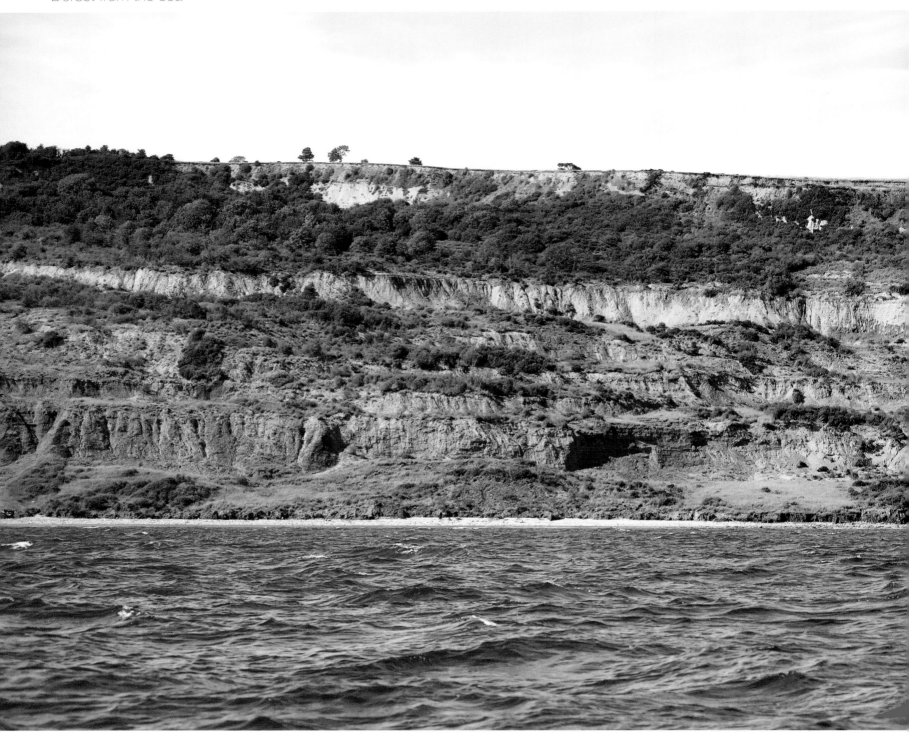

Black Ven and the Spittles landslip area near Lyme Regis.

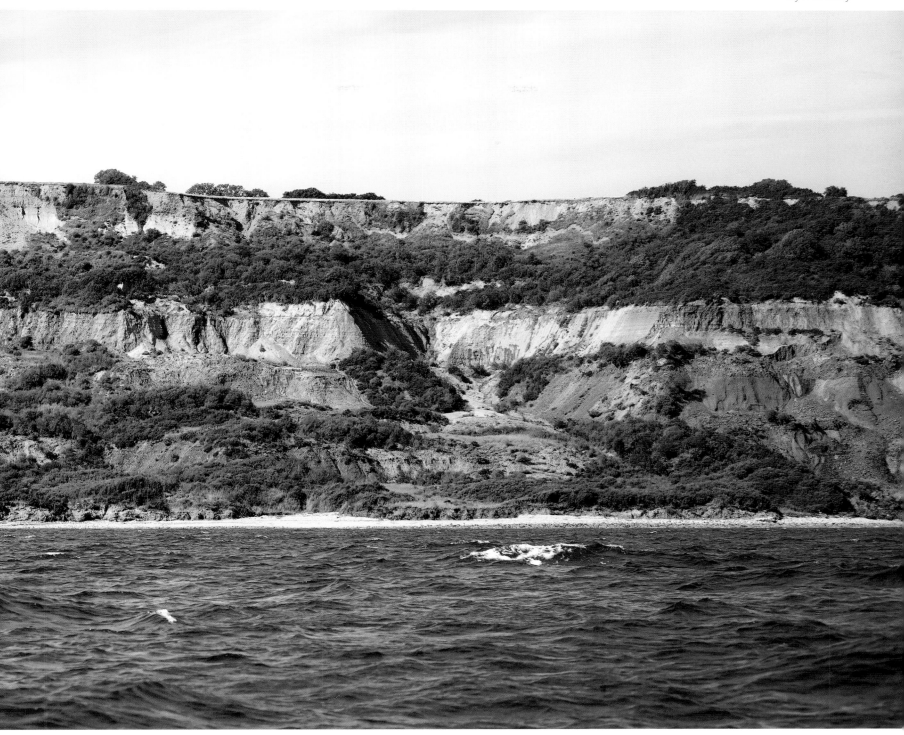

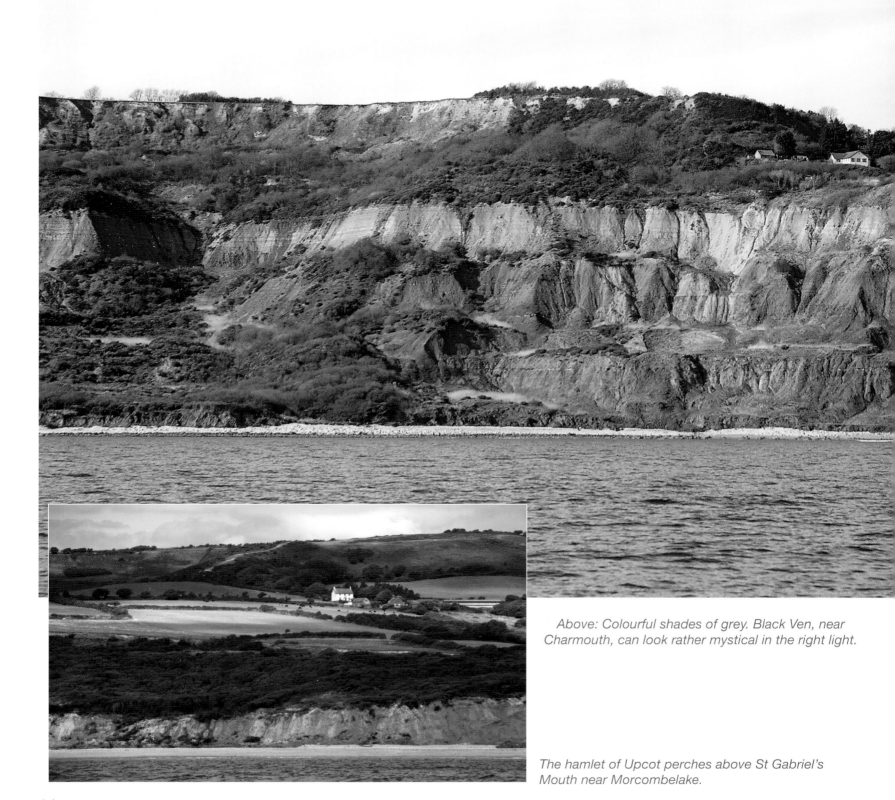

Above: Colourful shades of grey. Black Ven, near Charmouth, can look rather mystical in the right light.

The hamlet of Upcot perches above St Gabriel's Mouth near Morcombelake.

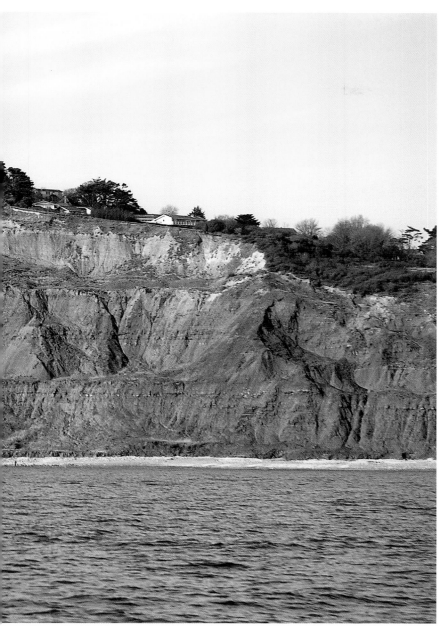

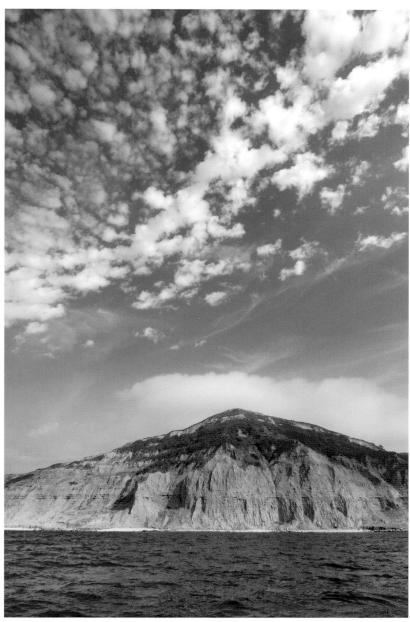

Golden Cap reaches up toward fluffy, fair-weather clouds in the morning. At 191 metres, it's the highest point on England's south coast.

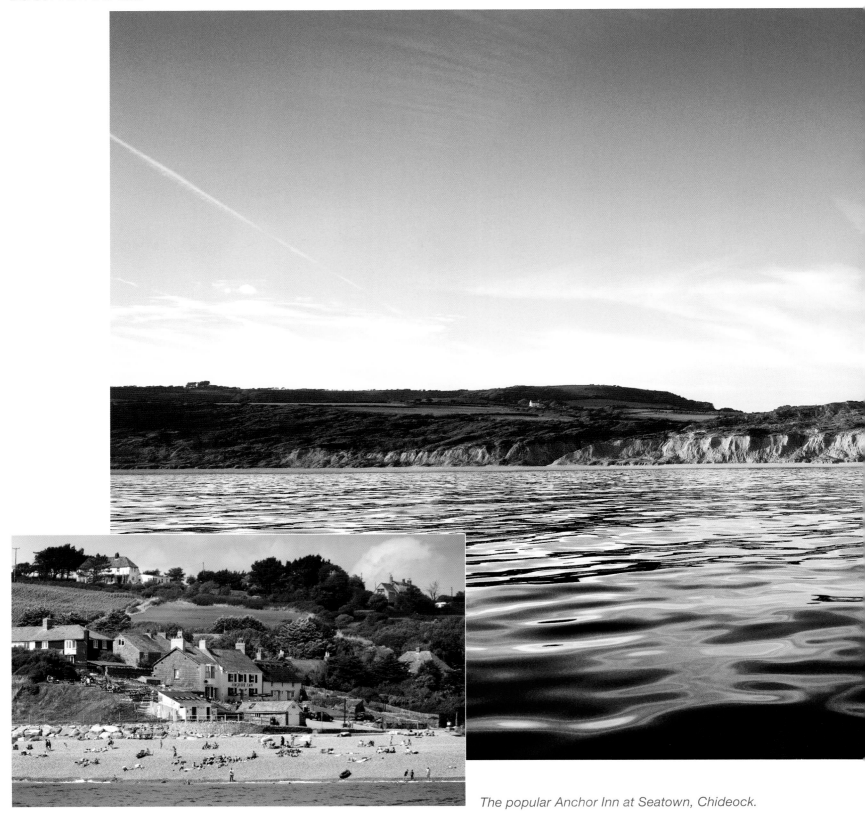

The popular Anchor Inn at Seatown, Chideock.

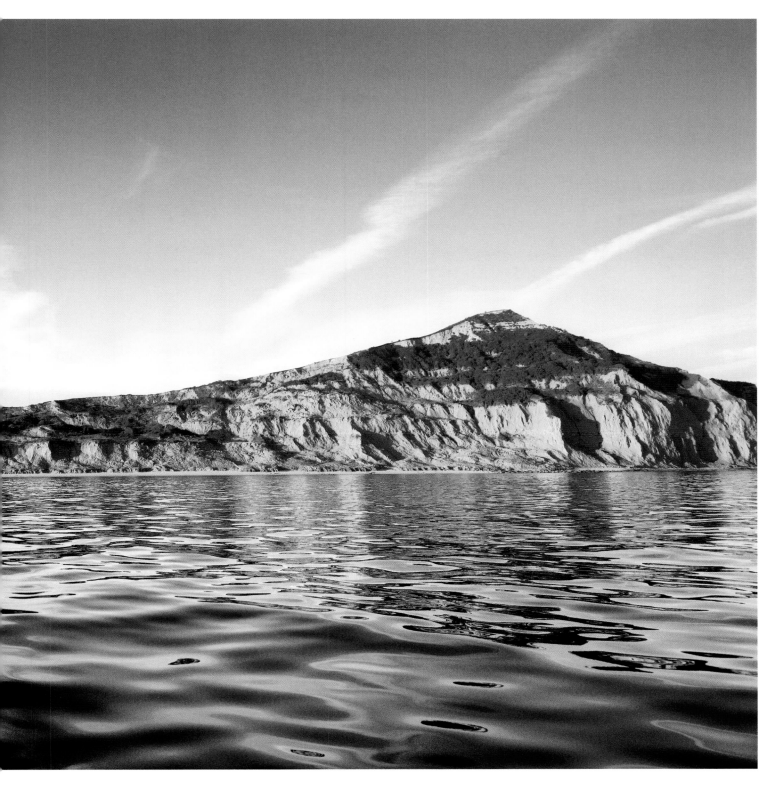

It's not just the peak of Golden Cap that glows in the evening sunshine. The whole hill and surrounding coast follow suit in the autumn. The curious St Gabriel's Mouth can just be seen towards the left.

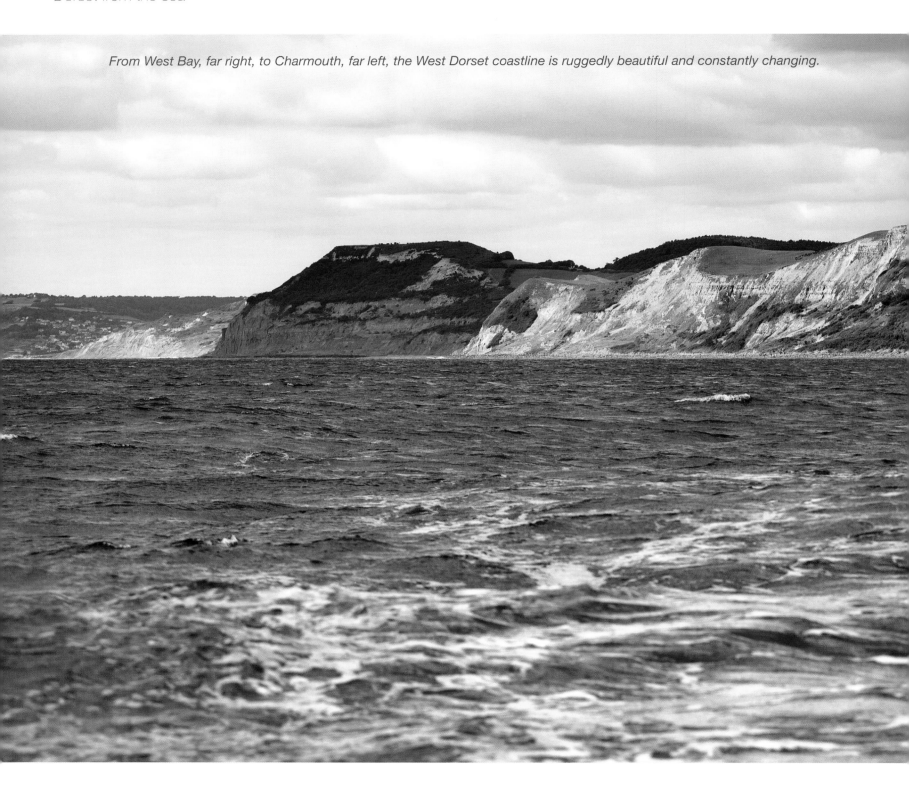

From West Bay, far right, to Charmouth, far left, the West Dorset coastline is ruggedly beautiful and constantly changing.

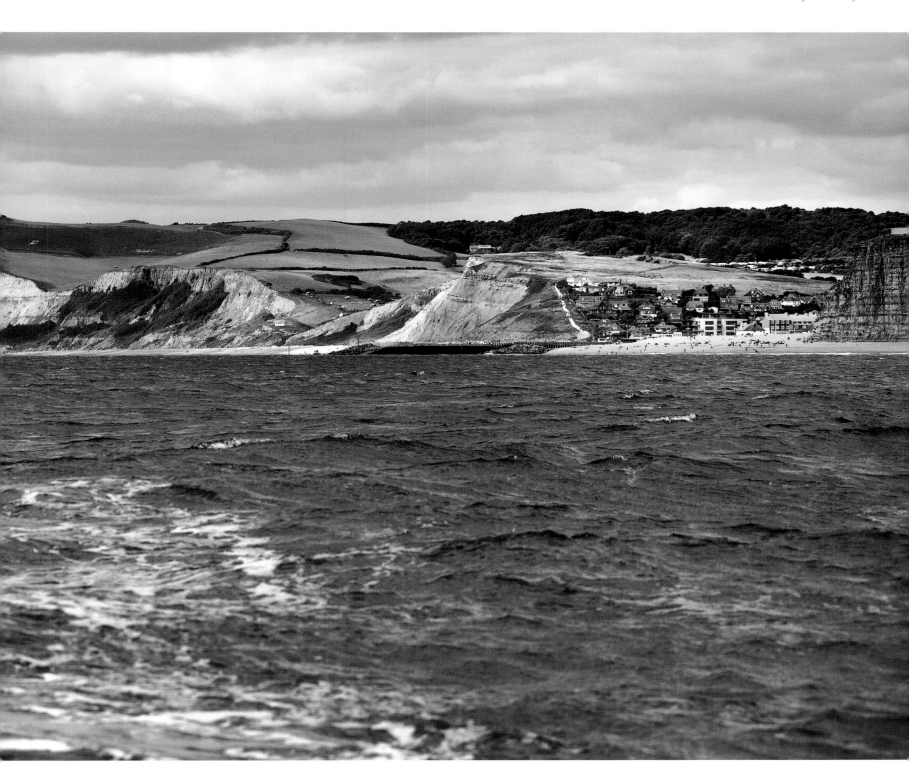

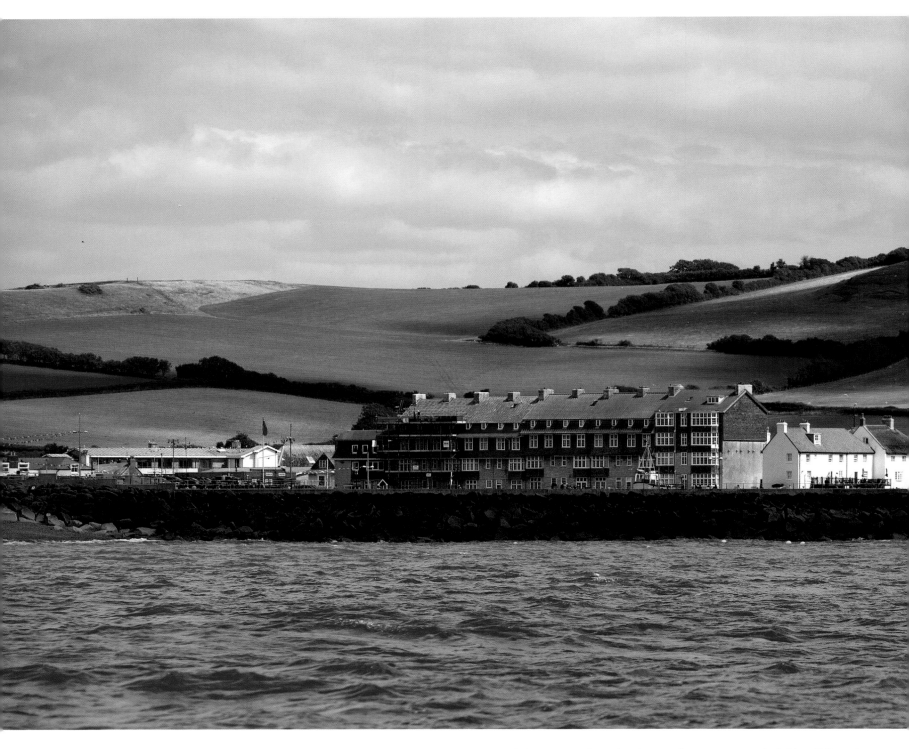

West Bay (originally Bridport Harbour) is at the mouth of the River Brit, near Bridport, and marks the north-western end of Chesil Beach. A large stone breakwater was built recently as part of a new coastal defence scheme, which also saw the harbour facilities extended with a new slipway and outer harbour.

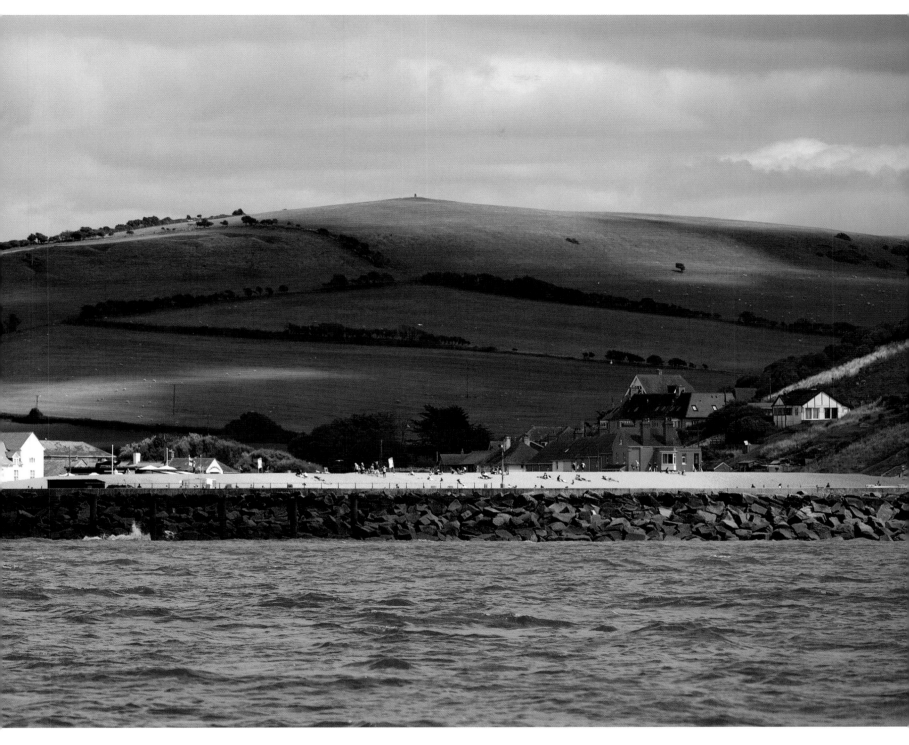

West Bay has been the location for such TV series as Harbour Lights, and, more recently, Broadchurch, and was the setting for the famous opening sequence of the BBC's Fall And Rise Of Reginald Perrin. The long, tall Pier Terrace was originally built as lodging houses for the expected, railway-delivered, late-Victorian tourists, who, alas, never materialised.

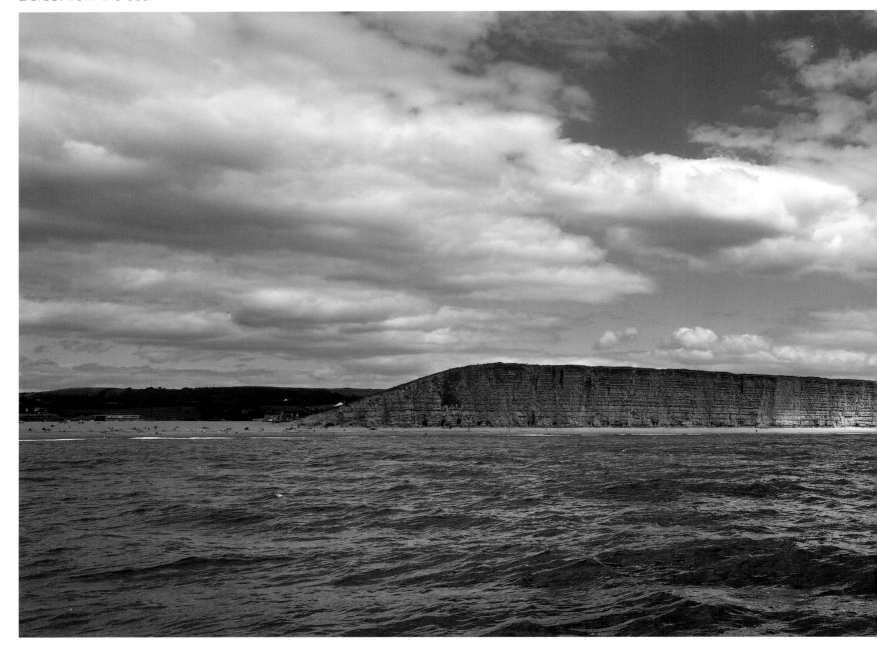

An expansive sky above, from left, West Bay beach, East Cliff, Freshwater, and Burton Cliff.

Opposite: The stunning, sandstone East Cliff glows in the evening light. Walkers enjoy the views from the top, while anglers cast from the beach. The cliff was the backdrop for the hit TV thriller series Broadchurch, and apparently one or two of the stars fell in love with the area and bought properties here ...

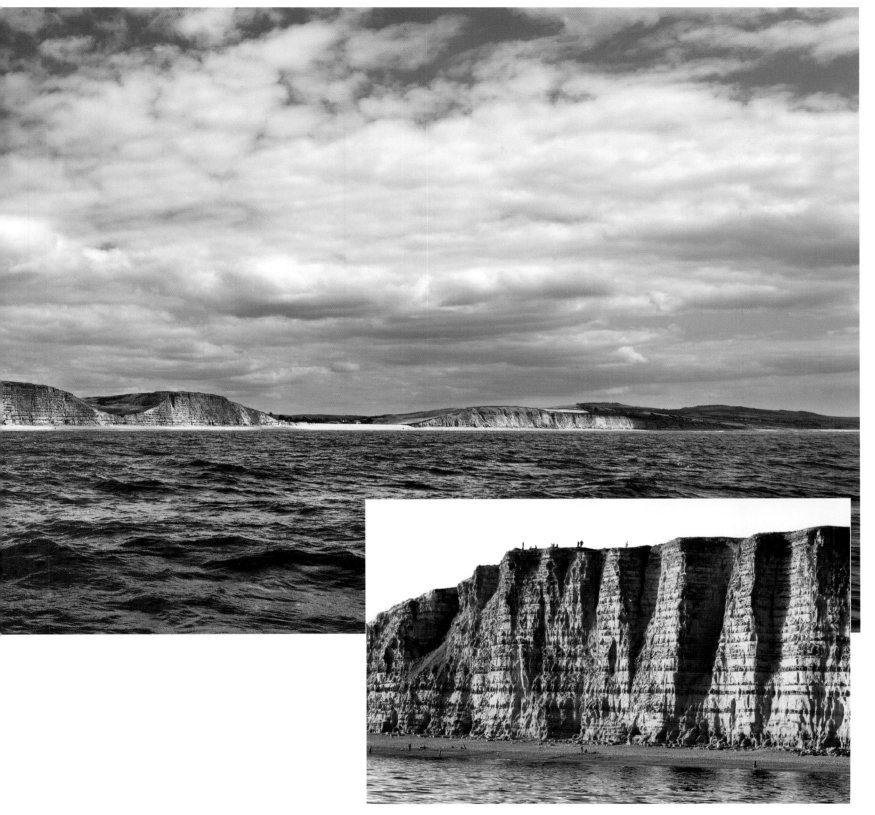

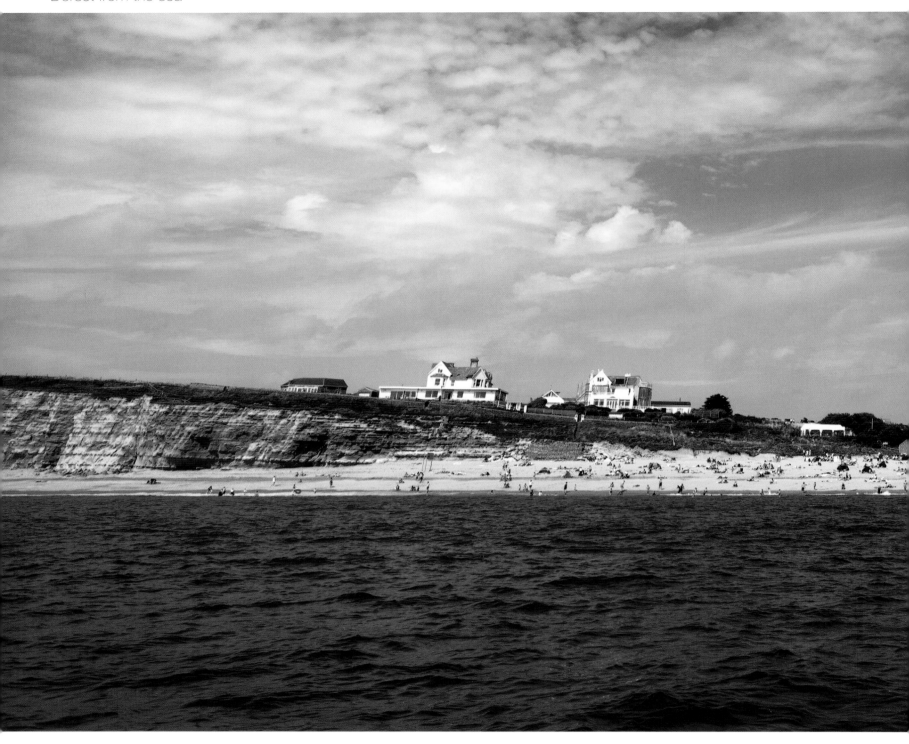

Hive Beach is very popular all year round, particularly because of its eponymous, award-winning cafe. The seafood there is legendary, and recommended by many, including TV chef Rick Stein.

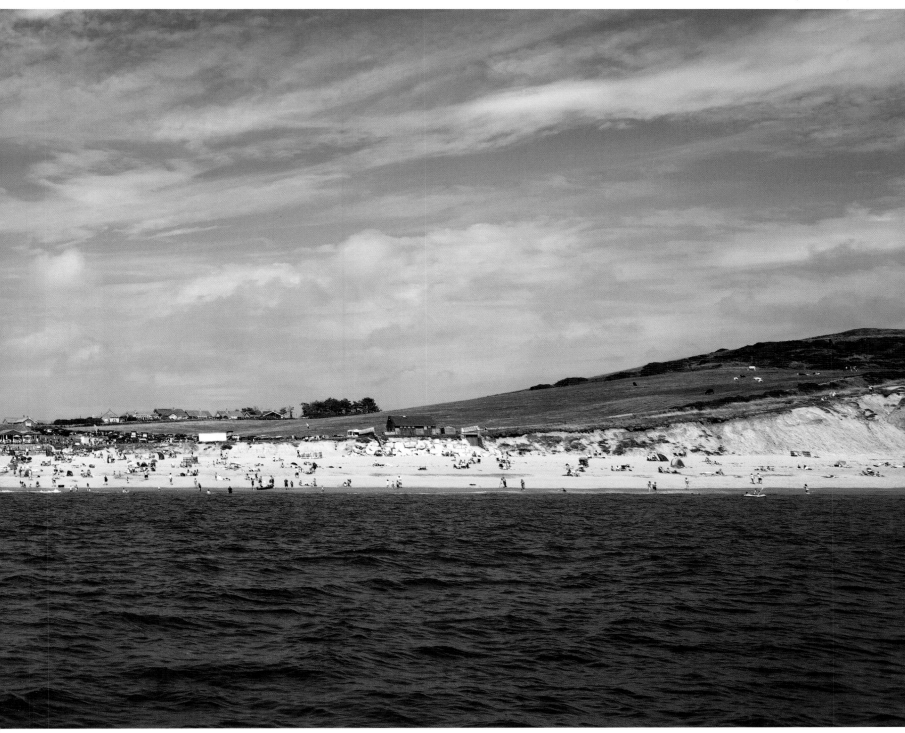

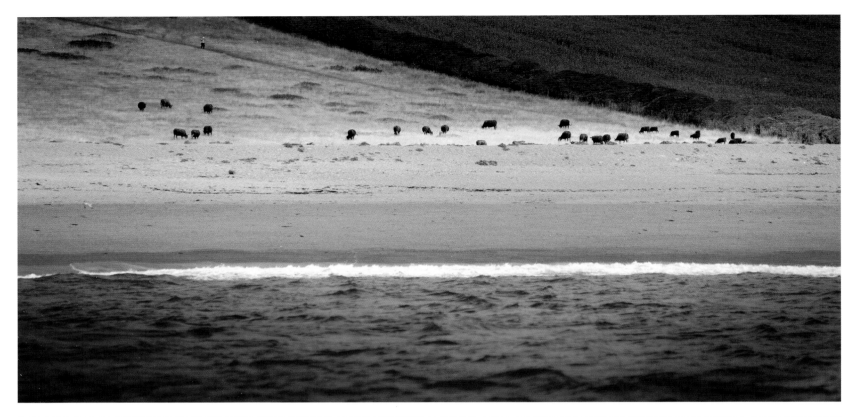

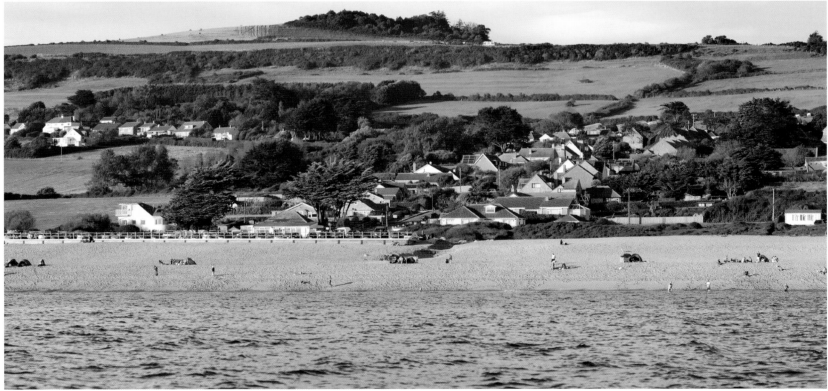

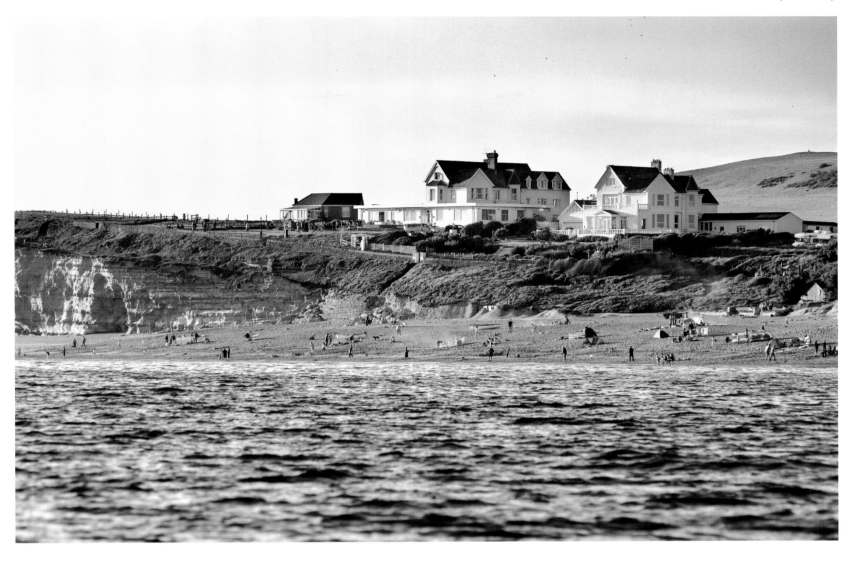

Perched on Burton Cliff, above Hive Beach at Burton Bradstock, are a matching pair of late-Victorian seaside villas, known as Barton Olivers and the Seaside Boarding House. They were originally built in the late 19th century, as holiday homes for a wealthy local family.

Opposite, top: Cattle graze in lush pastures behind Chesil Beach, near Swyre, like buffalo on a miniature prairie. The fascinating, yet largely barren, 18-mile-long barrier beach – comprised of an estimated 180 billion pebbles – was formed as sea levels rose rapidly after the last ice age. There is still debate over precisely how it developed.

Opposite: The village of West Bexington nestles above Chesil Beach. Some of the beach huts there have sold for nearly £300,000!

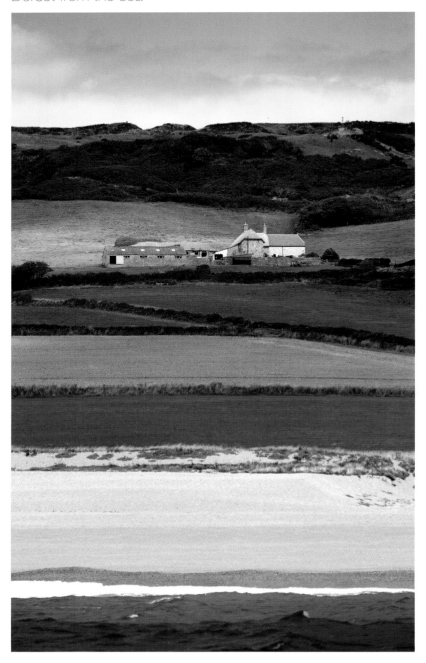

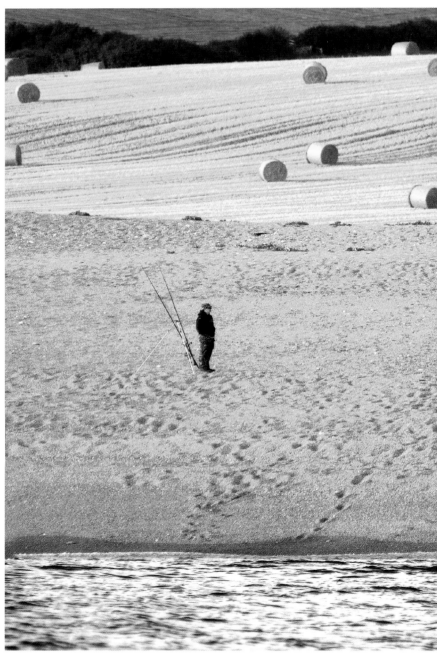

East Bexington Farm. The ramparts of the ancient Abbotsbury hill fort can be seen on the skyline.

Anglers on Chesil Beach. Hay is baled up ready for the winter, like toffee rolls. In autumn, the golden colour of the fields almost blends with that of the beach.

A pair of mute swans heads home to Abbotsbury Swannery, while a lone swimmer makes her way up the beach.

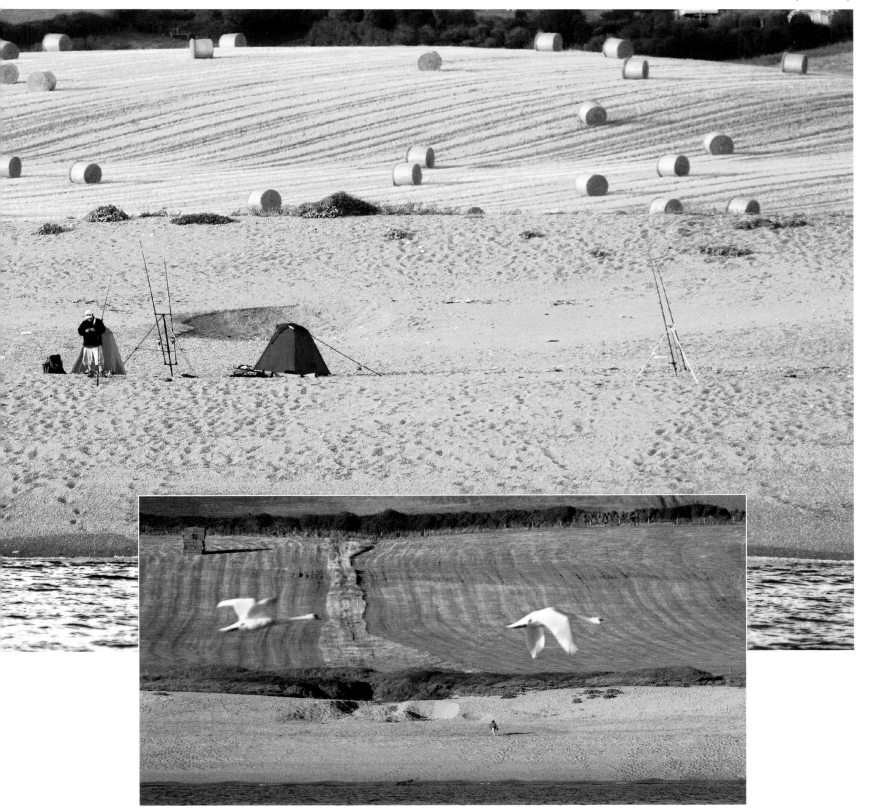

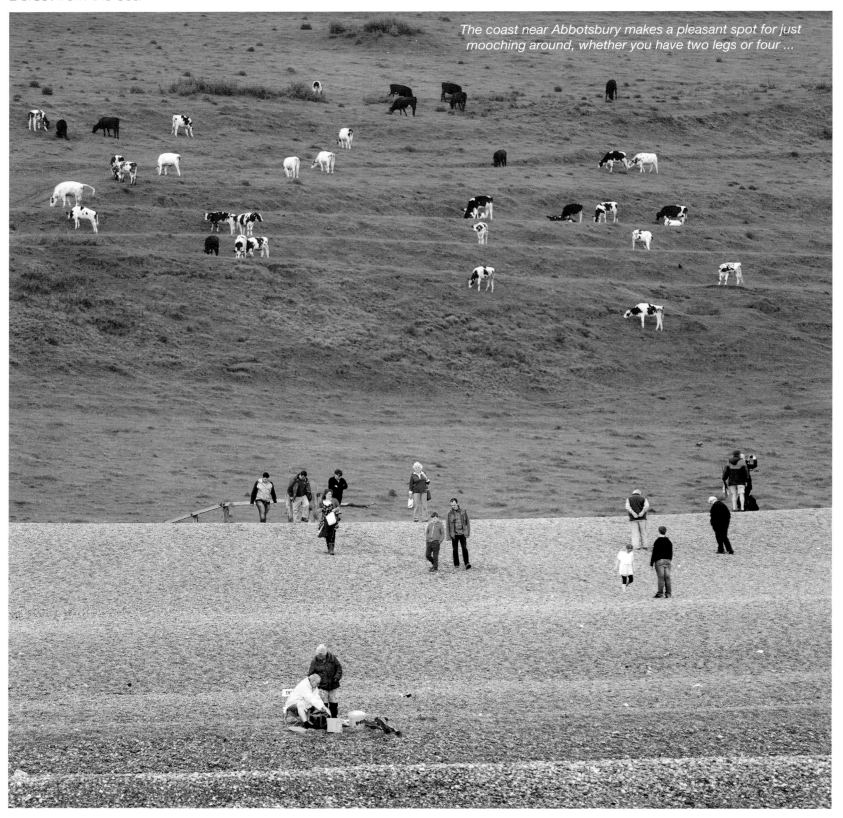

The coast near Abbotsbury makes a pleasant spot for just mooching around, whether you have two legs or four ...

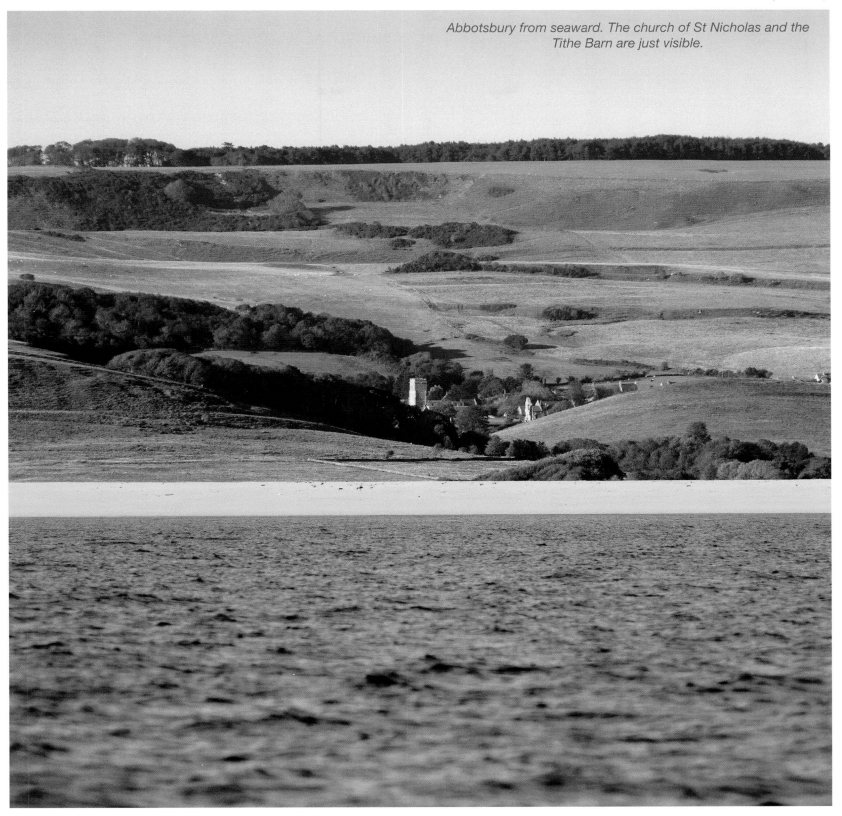

Abbotsbury from seaward. The church of St Nicholas and the Tithe Barn are just visible.

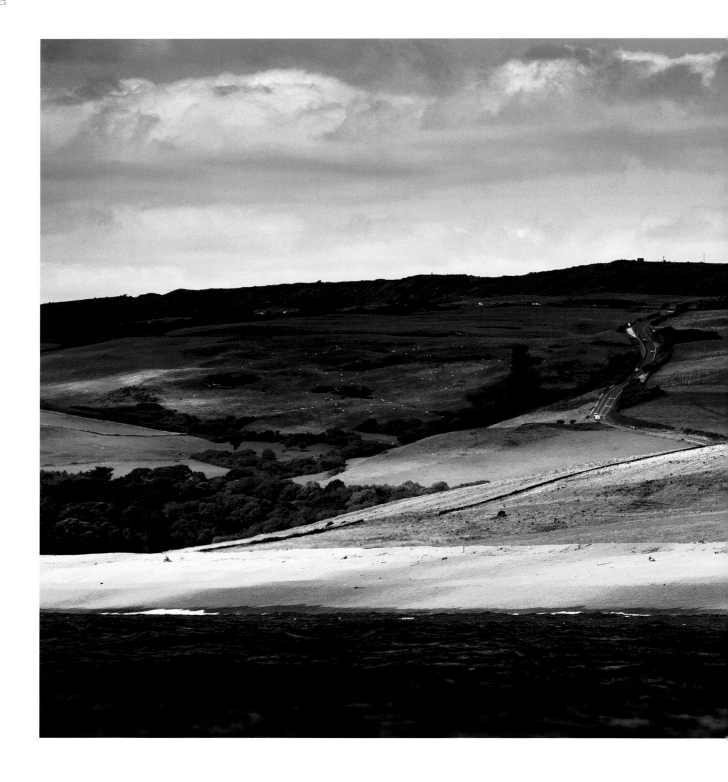

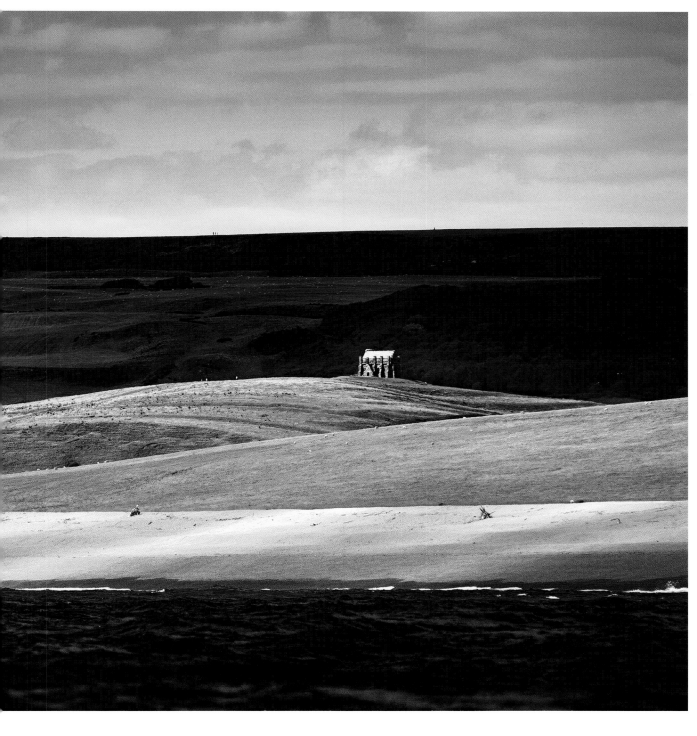

The 14th-century St Catherine's Chapel, near Abbotsbury, is a well-known 'sea-mark,' and occasional movie extra. It's one of the few chapels in the country built entirely from stone, including the roof. Legend has it that, for centuries, unmarried women have climbed the hill to the chapel to ask St Catherine, the patron saint of virgins, to deliver them a husband.
The B3157 coast road is very popular for its stunning views, but steep Abbotsbury Hill, in the distance, can be a challenge.

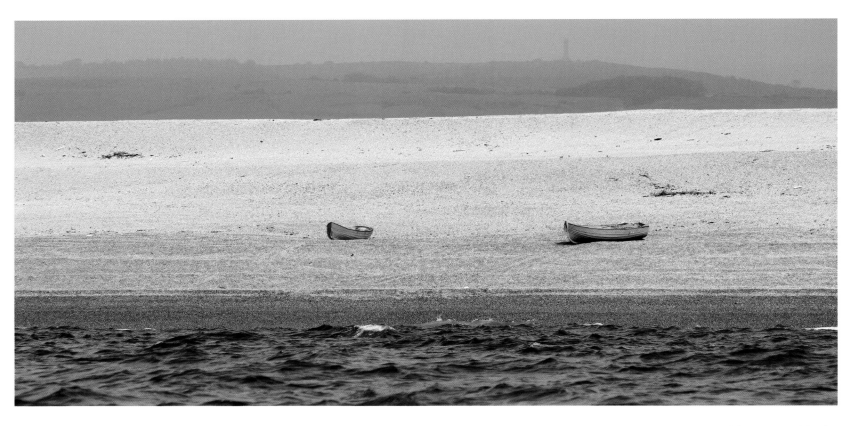

A pair of brightly-coloured boats stands out from the constancy of the Chesil Beach shingle. The monument to Thomas Masterman Hardy can just be seen on Blackdown in the blue haze.

Opposite: Portland Bill is left astern, sandwiched between sea and sky, as, on this occasion, the boat heads westward across Lyme Bay.

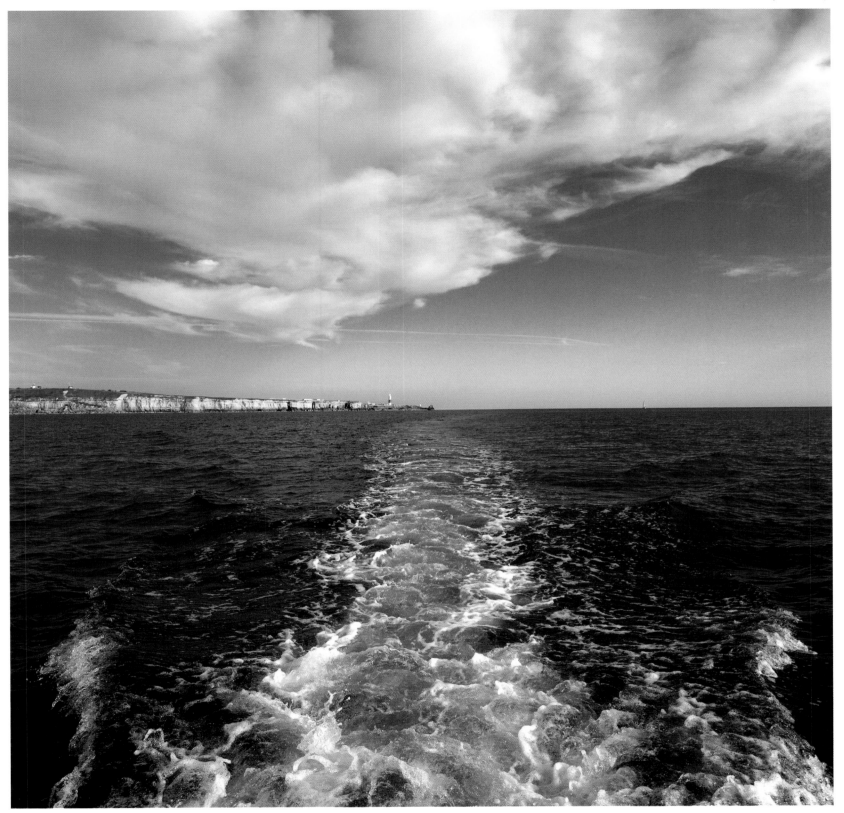

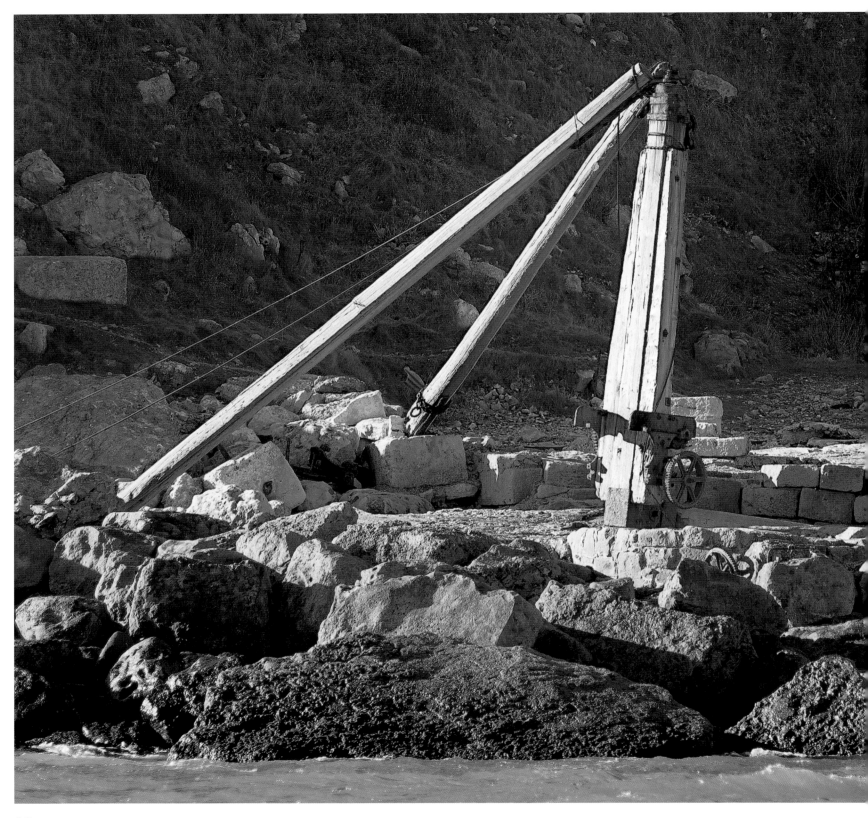

Portland & the harbour

From Chesil Cove to the centre of Portland Harbour is just over a mile as the gull flies, but it's a lot longer by sea. The gull, however, would miss out on the towering cliffs of Portland's west side, and the intricate caves, crags and tiny beaches that form the east of this long, limestone lump.

The west side seems a harsh and inhospitable place, with little access from the sea, and the tidal currents run hard, but it's still a playground for many. Once past the colourful village of Chiswell you can find climbers tackling fallen rocks the size of supermarkets, ornithologists keeping an eye out for puffins, and a plethora of colourful pot buoys giving evidence of the providence of these waters.

On a sunny evening, though, it all becomes beautifully austere, with the grey limestone taking on a much warmer hue, and plunging down into deep blue waters.

The much-visited Bill (originally Beal), needs little introduction, with a total of three lighthouses still standing, and dozens of colourful huts.

A stretch of sandstone here has allowed the development of chasms and caves, which, when viewed from my small boat, are both fascinating and a little sinister, though much beloved of those who enjoy fishing, climbing and coasteering.

There's plenty of coastal archaeology here, too: the remains of Portland's legendary quarrying industry – ancient, hand-operated cranes and stacks of neatly-carved stone blocks piled up ready for the ships that never came once road transport flourished.

The vast breakwaters of Portland Harbour enclose the second-largest man-made harbour in the world, and its accompanying maritime activity. This ranges from kite-surfing to cruise shipping; spear-fishing to torpedo testing (well, in days gone by ...), and, of course, every type of sailing you could imagine.

This circumnavigation of Hardy's 'Isle of Slingers' may only be a lightweight ten miles, but it punches way above its weight in terms of world-class marvels – natural and man-made.

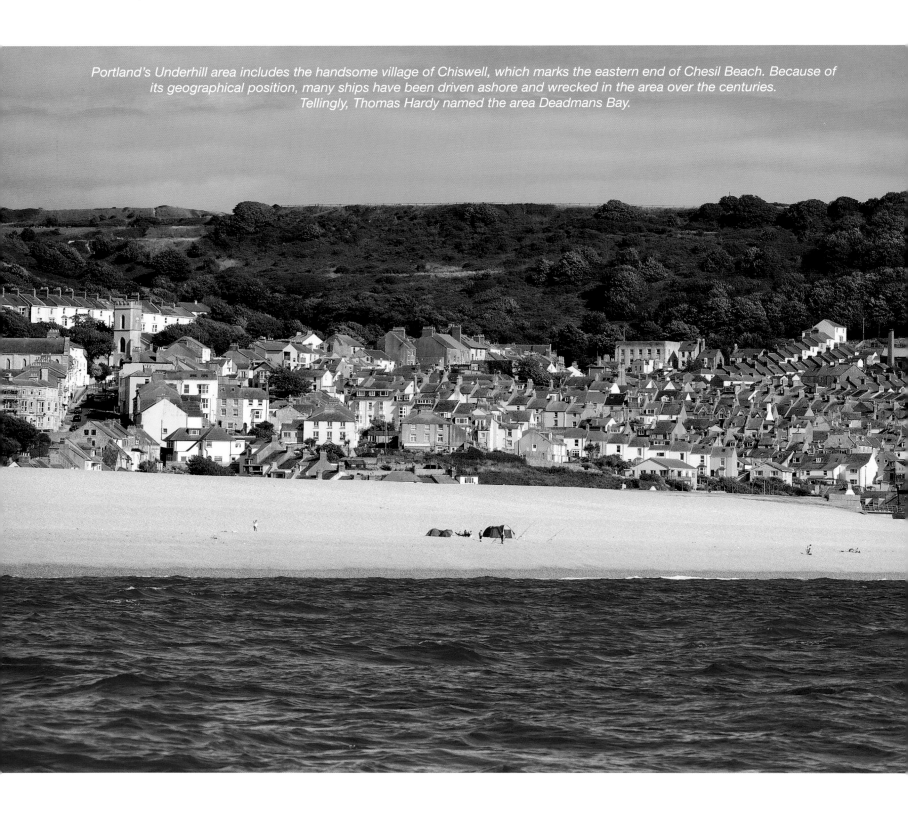

Portland's Underhill area includes the handsome village of Chiswell, which marks the eastern end of Chesil Beach. Because of its geographical position, many ships have been driven ashore and wrecked in the area over the centuries. Tellingly, Thomas Hardy named the area Deadmans Bay.

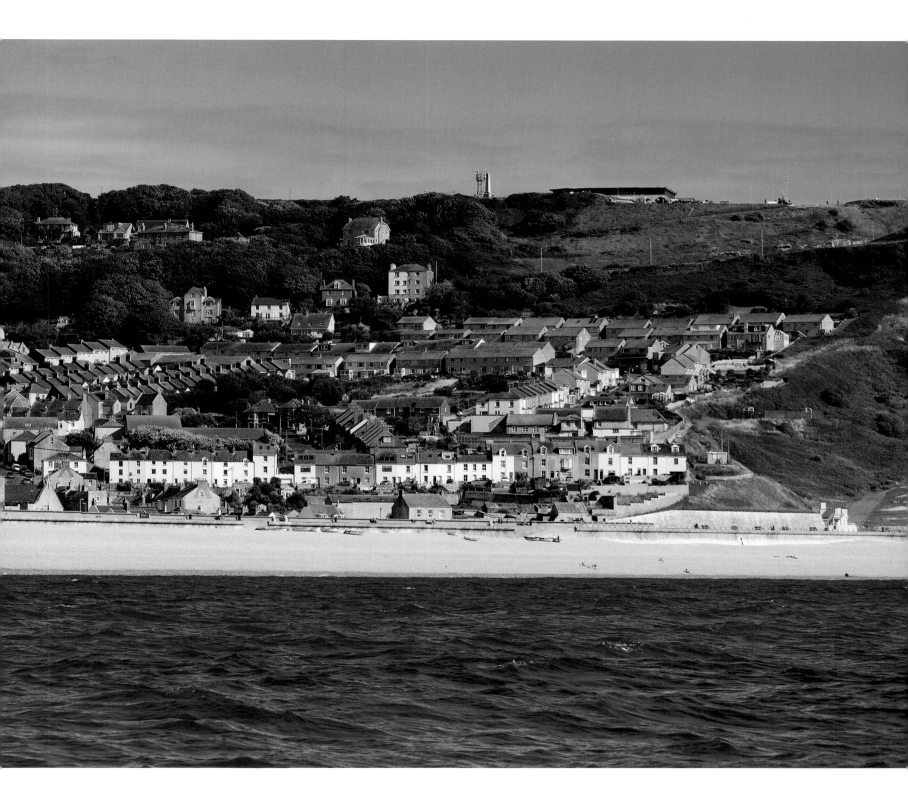

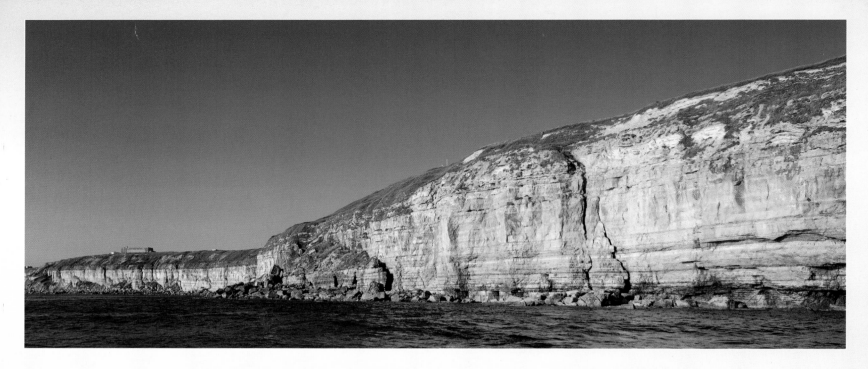

Wallsend, Mutton Cove, and Blacknor. Southwell Business Park is just visible.

Main pic: The top of towering Blacknor is the site of a Victorian fort completed around 1902 as a coastal defence against enemy vessels on the west side of the island.

Inset, right: The awesome west side of Portland is a playground for many. Climbers tackle fallen rocks the size of supermarkets, and ornithologists keep an eye out for puffins.

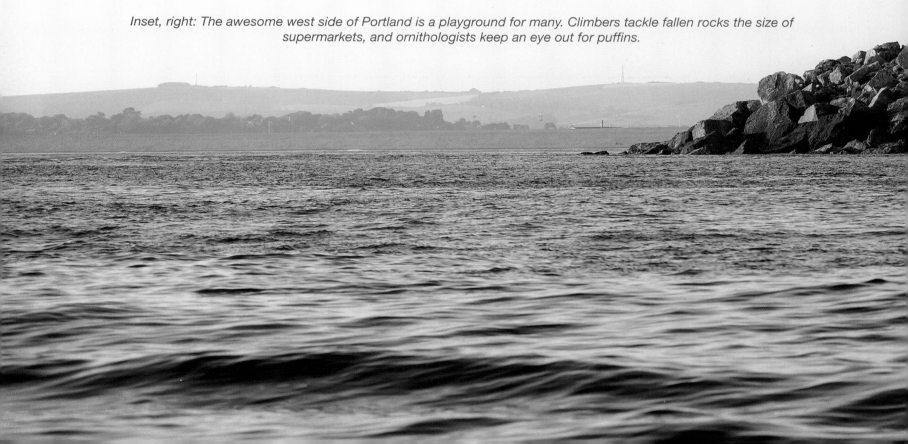

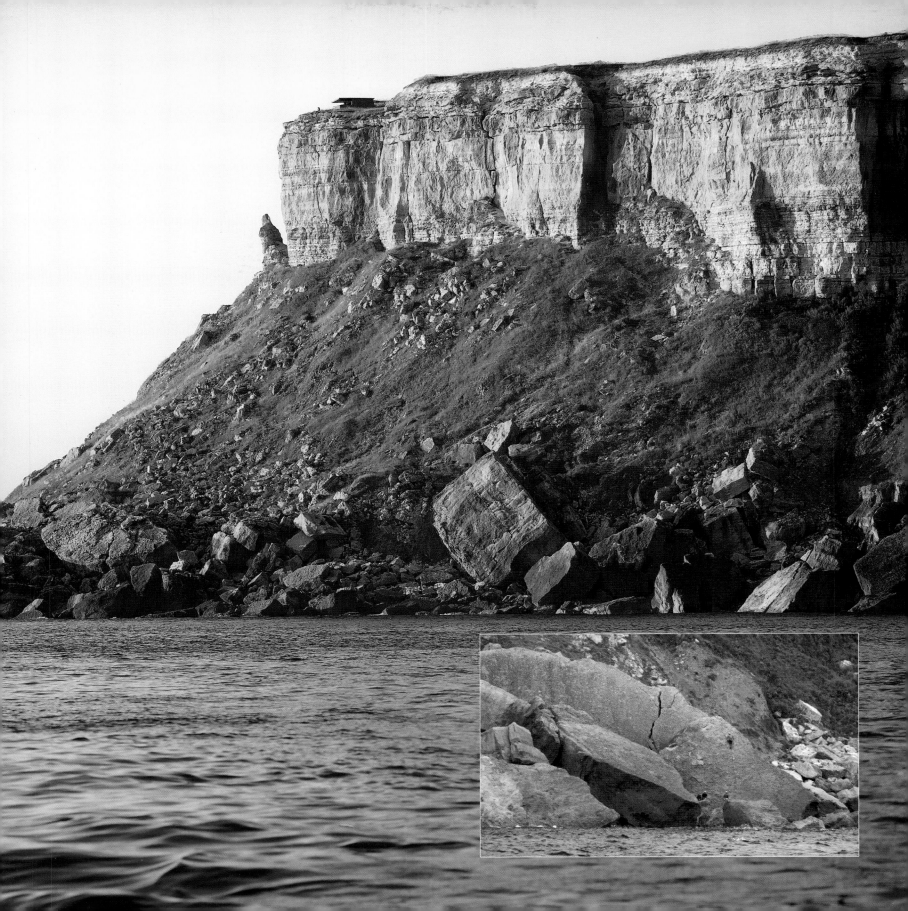

On a calm day the notorious headland looks as gentle as a lamb ... but it's ferocious when the wind's blowing.
The 41-metre lighthouse tower was built in 1906. The seven-metre-high obelisk is engraved 'TH' – not for Dorset's most famous writer,
but for Trinity House, which established the first light at the Bill in 1716.
Sadly, lighthouse keepers are no more, and, since 1996, the light has been operated remotely from Harwich in East Anglia!

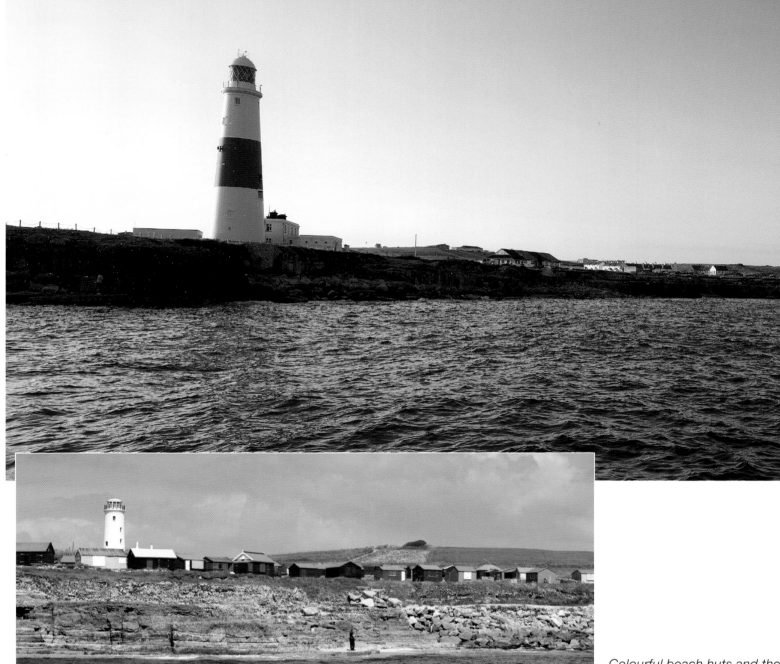

Colourful beach huts and the old Portland Low lighthouse; now a bird observatory.

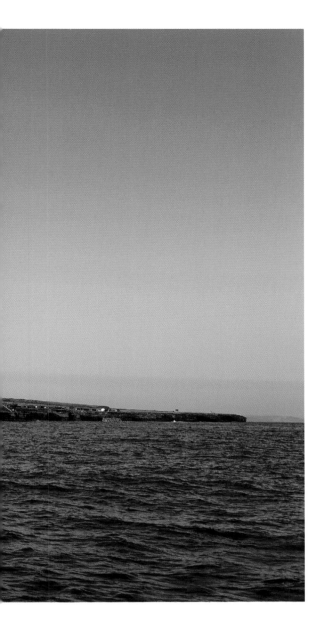

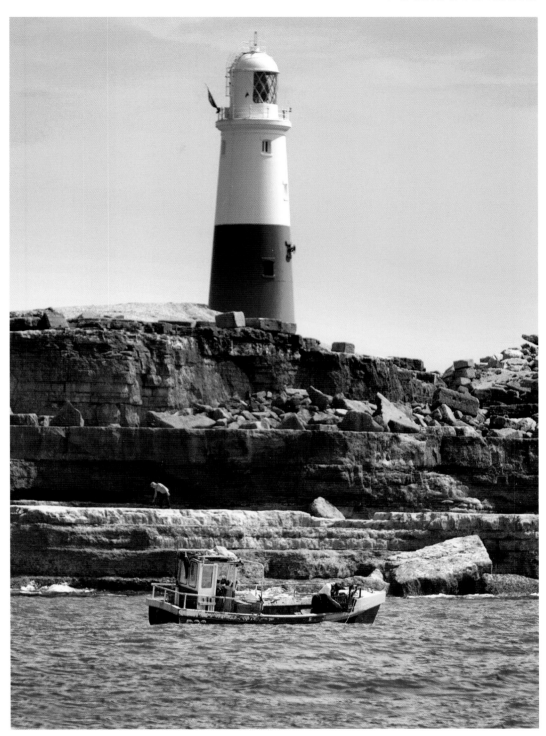

A pot boat at work in the productive waters around the Bill.

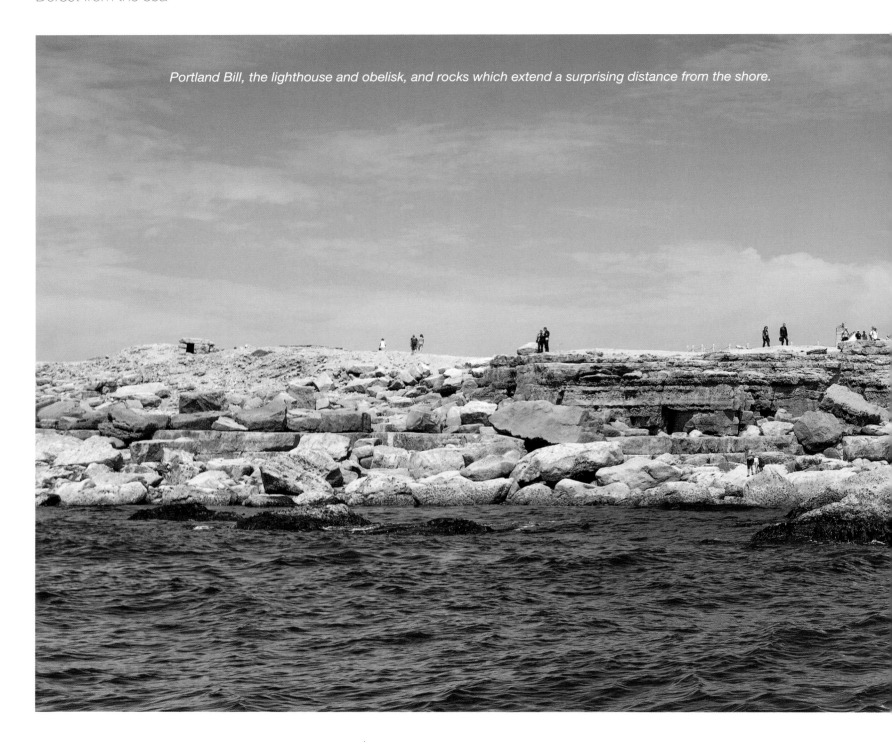

Portland Bill, the lighthouse and obelisk, and rocks which extend a surprising distance from the shore.

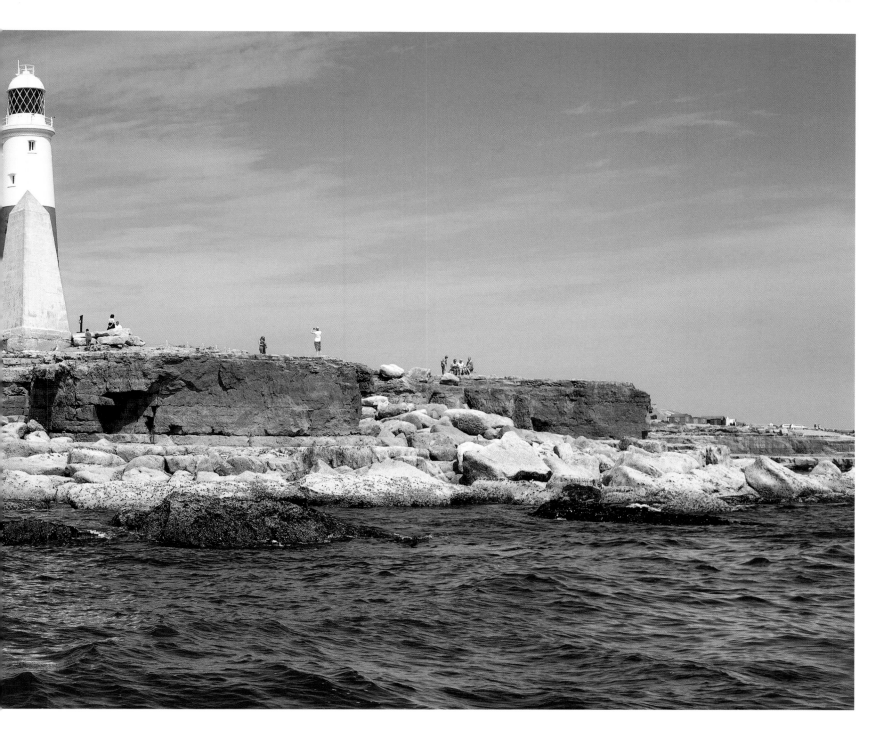

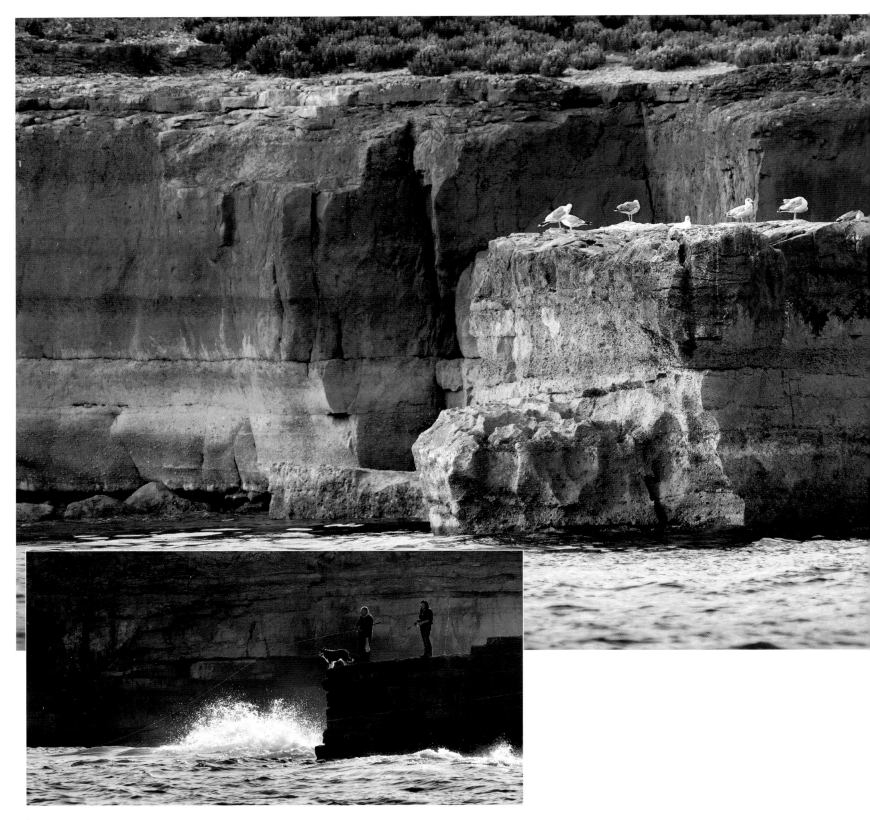

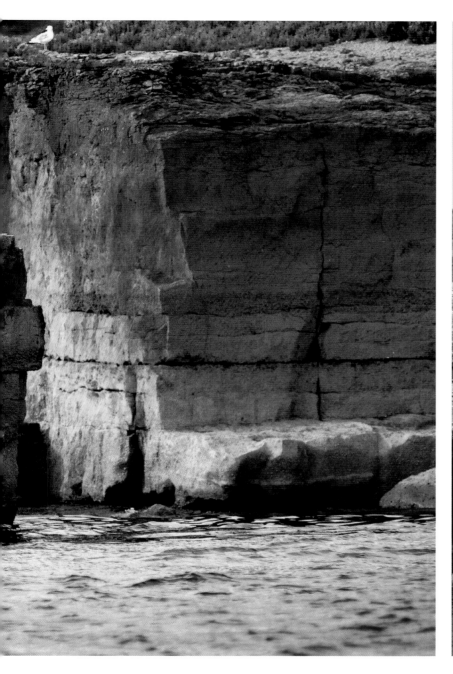

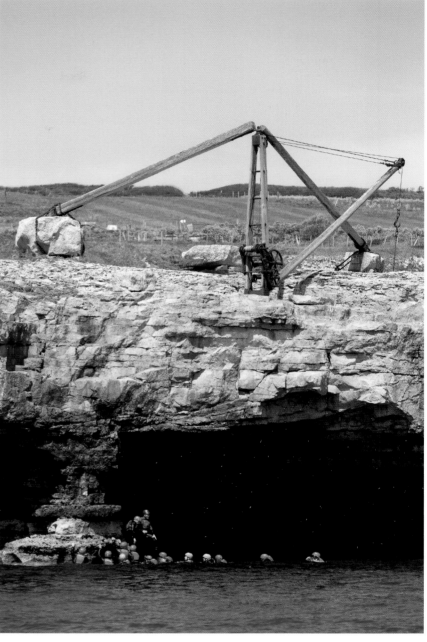

Right: The caves at Sandholes in the south east of the island are popular for the fast-growing sport of coasteering, which involves climbing rocks, swimming, climbing more rocks, then more swimming, etc. (I think these guys are crazy but I'm sure it's fun.) One of Portland's few surviving boat-launching cranes is sited here.

Main pic: Robinson Crusoe island, near the Bill, is formed from an area of mellow-coloured sandstone.

Inset: The island's myriad nooks, crannies and ledges provide a haven for fish and other wildlife. Whichever way the wind blows, there's usually a sheltered spot for anglers to seek out wrasse, bass, and dozens more species for which the island is renowned.

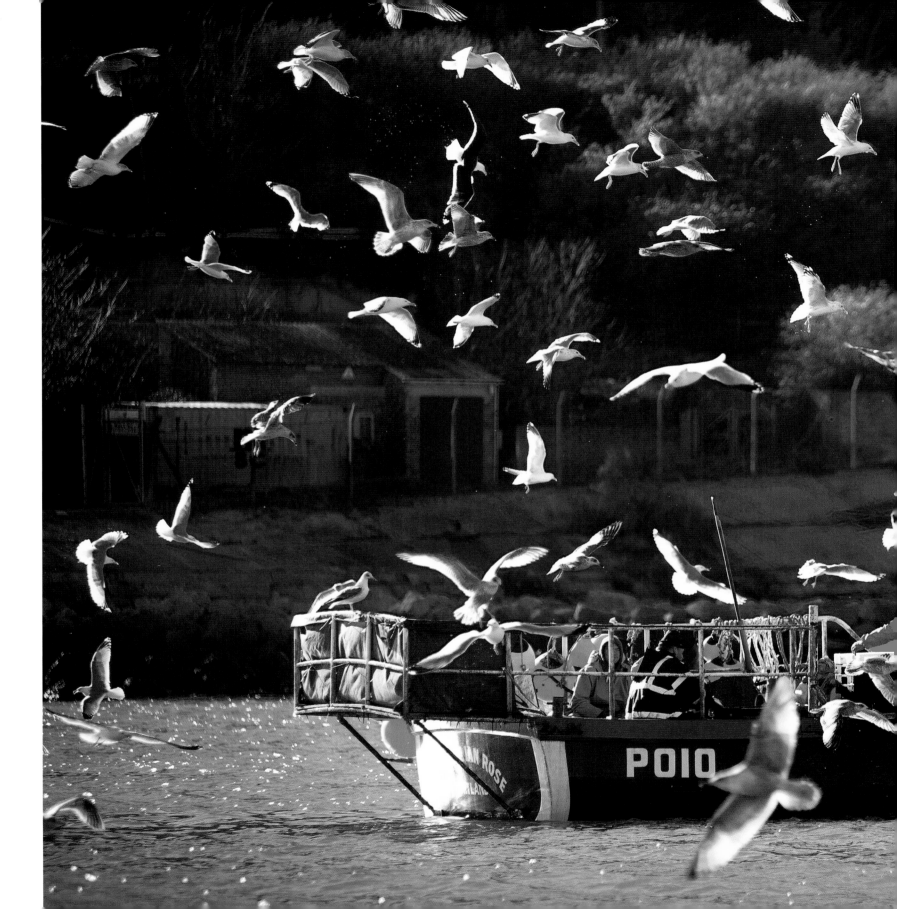

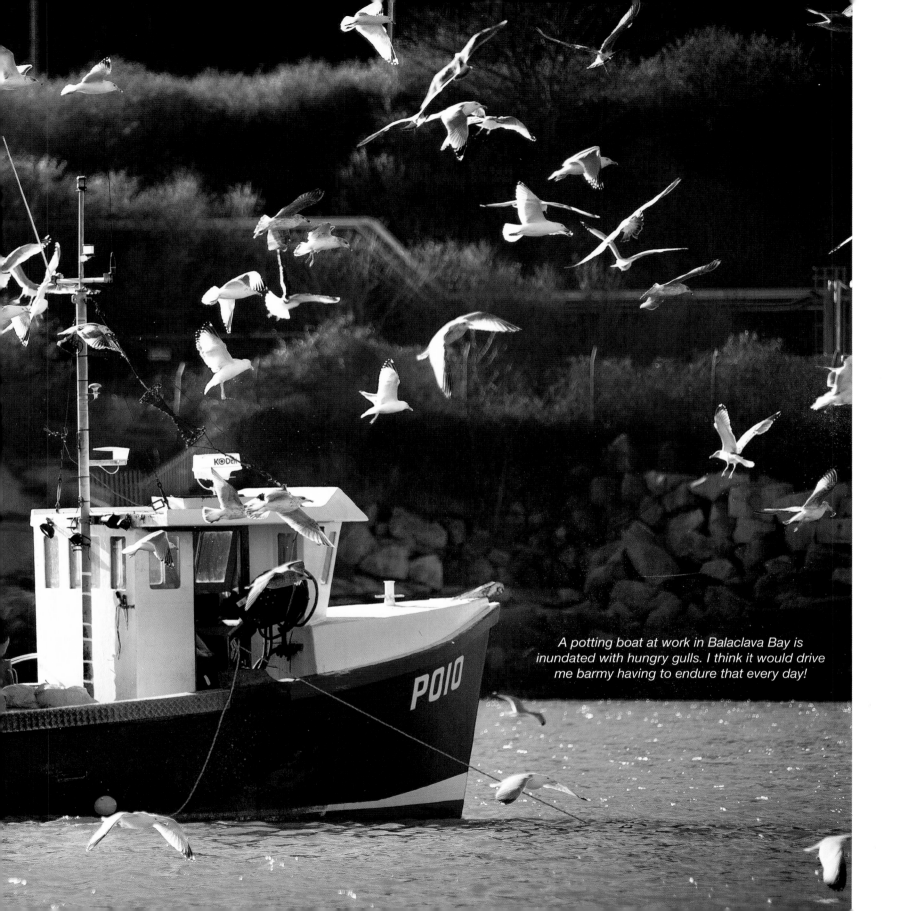

A potting boat at work in Balaclava Bay is inundated with hungry gulls. I think it would drive me barmy having to endure that every day!

Colourful beach huts at Church Ope Cove. The remains of Rufus Castle (known locally as Bow and Arrow Castle), tower above to the right of the cove. This late 15th-century castle was built on the site of a much earlier one.

Portland, grey? Set high above the verdant landslips of East Weares, Nicodemus Knob is a ten-metre-high landmark. It was left by quarrymen to mark the original height of the island before quarrying activities began to supply the stone for the Portland breakwaters. The major landslip here took place in 1792, and is the second largest recorded in Great Britain. More than a mile of land slipped down some 50 feet.

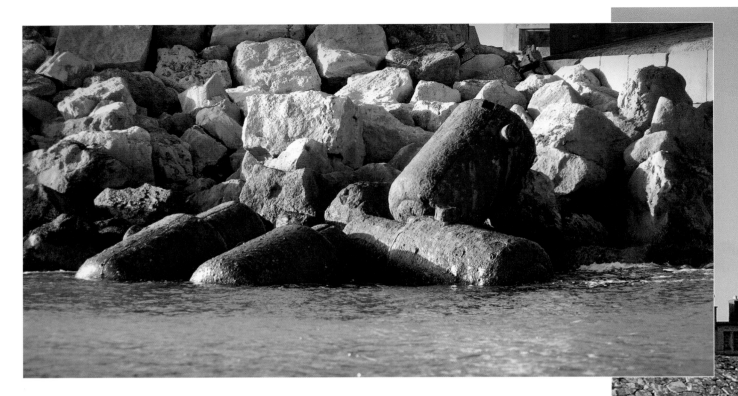

First World War cannon breeches, which were deemed too awkward to remove when the fort was abandoned, can still be clearly seen.

The vast, 19th-century breakwaters of Portland Harbour, the second largest man-made harbour in the world, were built to defend the Royal Navy's warships at anchor. At the head of the mile-long Outer Breakwater lies the imposing Chequered Fort. It's one of the four Victorian iron forts built along the south coast, with one at Plymouth and two near Portsmouth, originally to protect the south coast against an anticipated attack by the French.

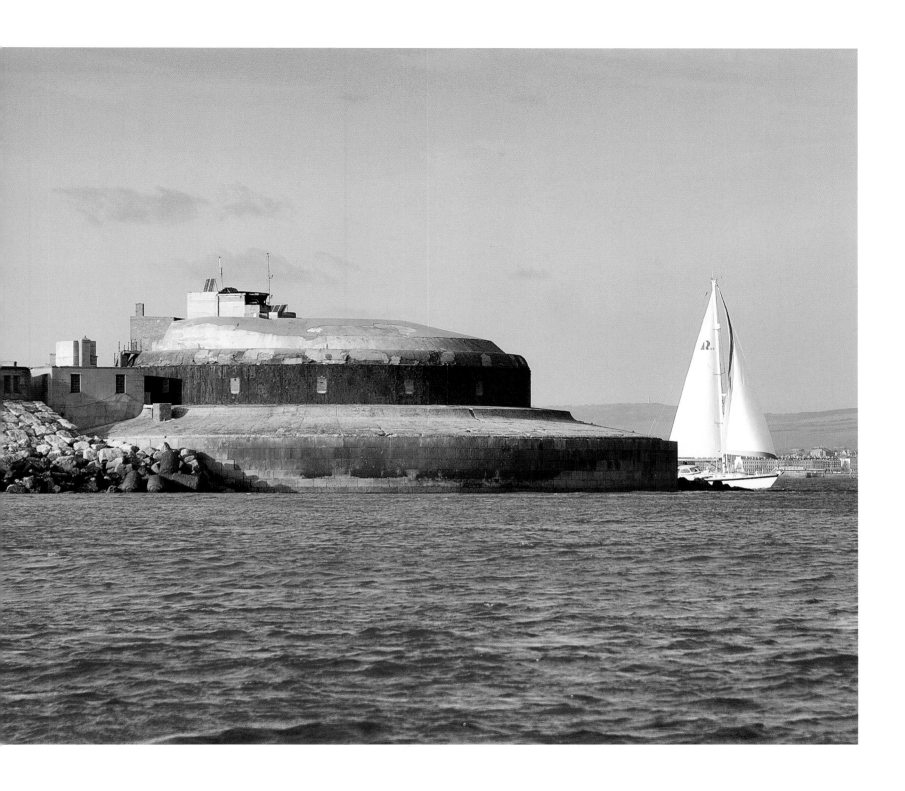

HMS Portland pays a civic visit to her namesake island. In years gone by, the former officers' quarters, pictured behind the Type 23 frigate, may have housed some of her officers, while the colourful Castletown pubs would probably have played host to many of her ratings!

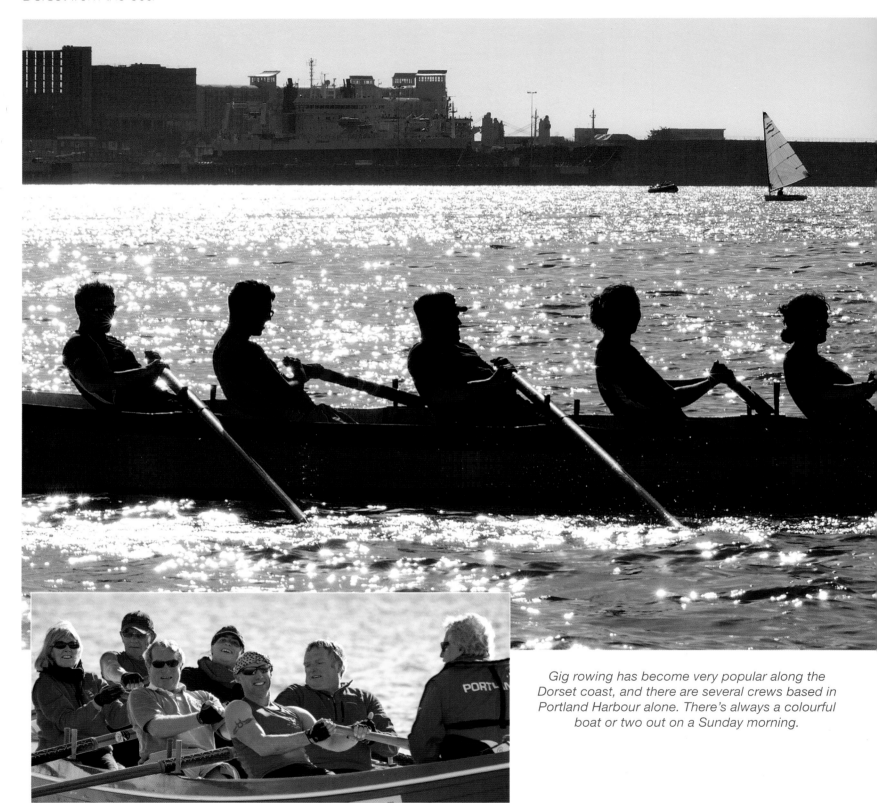

Gig rowing has become very popular along the Dorset coast, and there are several crews based in Portland Harbour alone. There's always a colourful boat or two out on a Sunday morning.

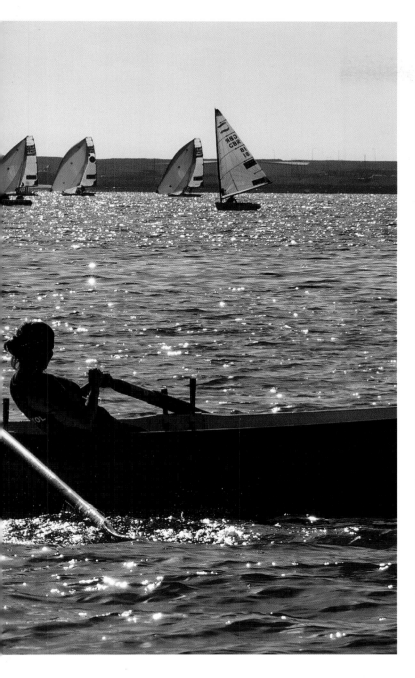

Partisan support for local sailors was rife during the Olympic events of 2012, with many locals wearing their hearts on their, er, sails ...

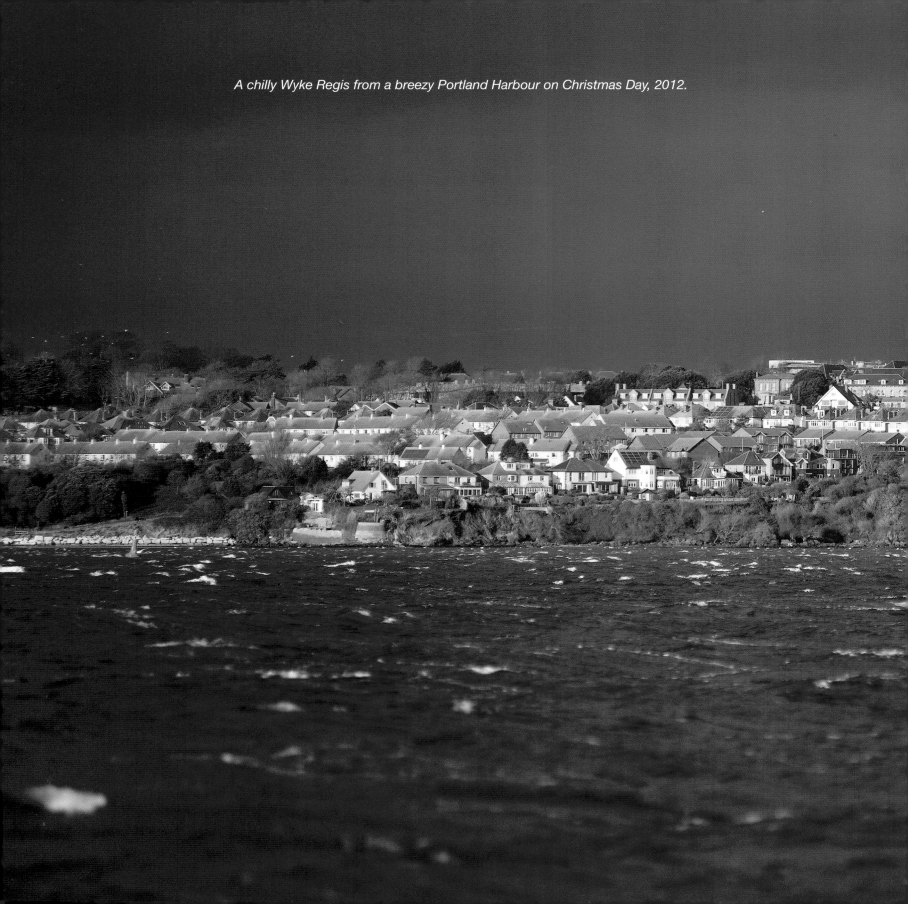

A chilly Wyke Regis from a breezy Portland Harbour on Christmas Day, 2012.

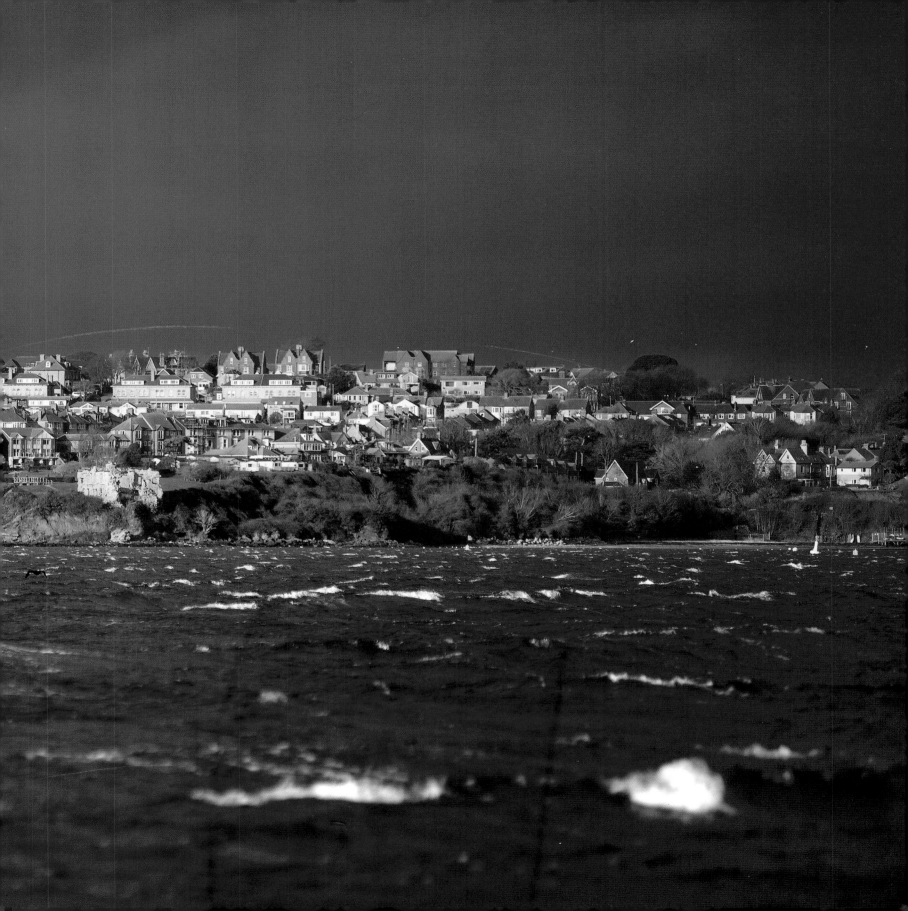

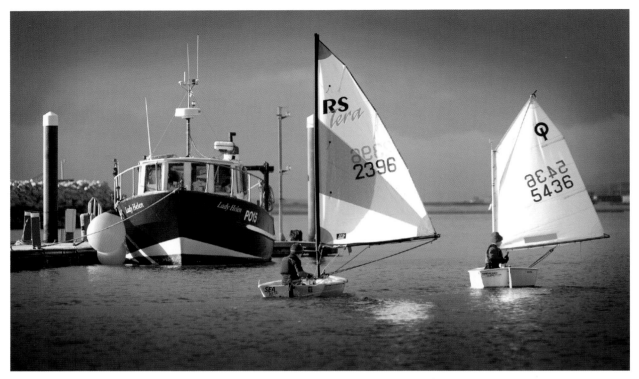

Sailing takes place all through the year in the harbour, for enthusiasts of all ages. Here, a couple of hardy youngsters enjoy a gentle sail on a February afternoon.

Little terns are a common sight around Ferrybridge in Portland Harbour. A colony of the Schedule 1-protected birds nests on a nearby stretch of Chesil Beach.

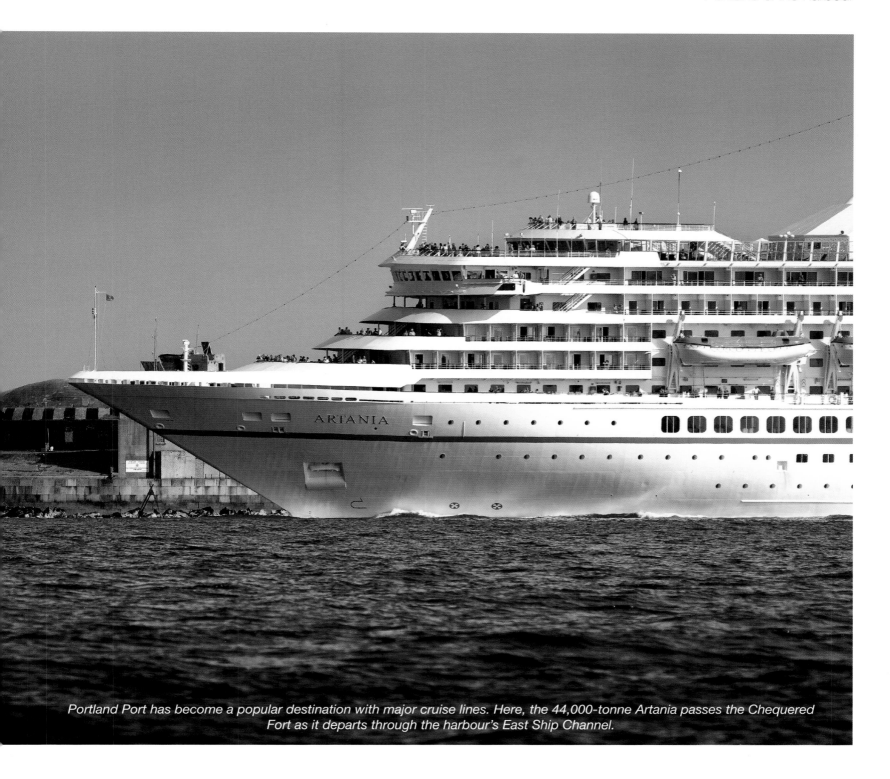

Portland Port has become a popular destination with major cruise lines. Here, the 44,000-tonne Artania passes the Chequered Fort as it departs through the harbour's East Ship Channel.

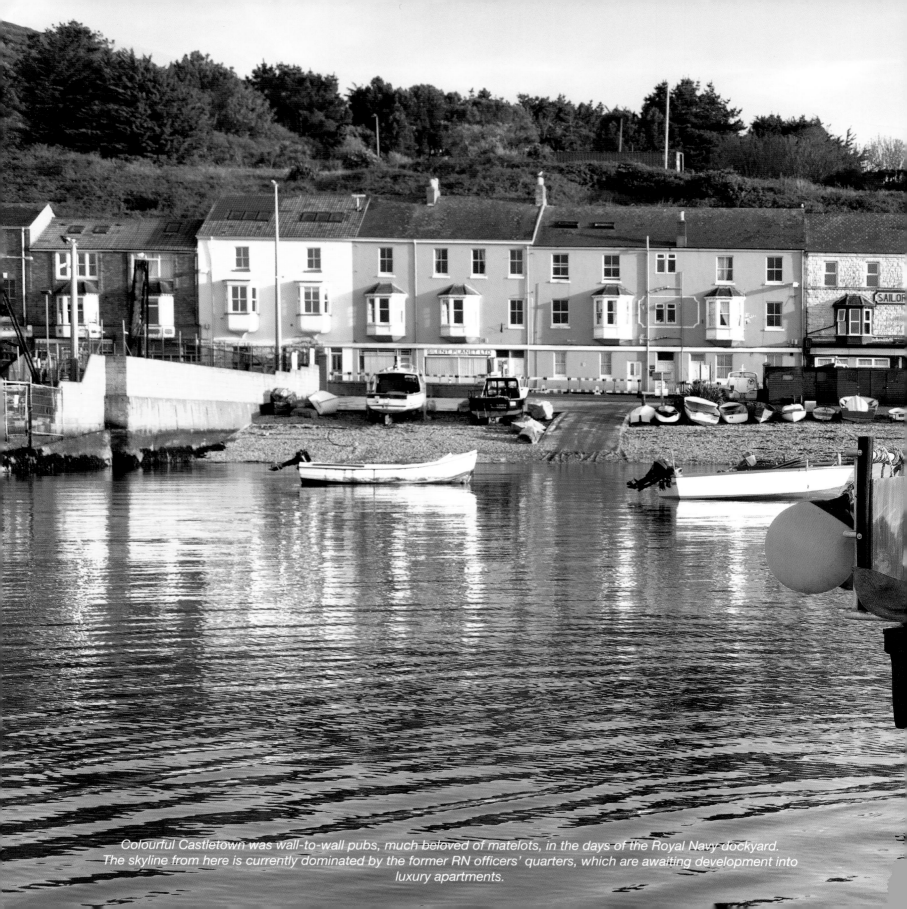

Colourful Castletown was wall-to-wall pubs, much beloved of matelots, in the days of the Royal Navy dockyard. The skyline from here is currently dominated by the former RN officers' quarters, which are awaiting development into luxury apartments.

Day or night, when leaving (or arriving at) Weymouth's Inner Harbour, motorboats can go under the lifting Town Bridge. However, for obvious reasons, sailing boats have to wait for it to open!

Weymouth & the bay

Weymouth and its bay have many claims to fame, including being the subjects of paintings by Constable and Turner. Most people know Weymouth, however, for its gently shelving, family-friendly beach; one of the safest and cleanest in the country.

The sandy seafront, with its colourful Georgian Esplanade, looks resplendent all year round, the best view of which is from offshore.

On the way to getting that vista you encounter myriad thrill-seekers and workers, cheek by jowl out in the bay: anglers in tiny kayaks dwarfed by visiting warships; huge tankers at anchor, and diminutive jet-skiers bouncing off the wakes left by the brightly-coloured fishing boats.

The pretty and busy harbour still has an active fishing fleet, but its most infamous boast is being the port where the devastating Black Death first entered England, in June 1348.

On a more positive note, the bay was also the embarkation point for the US First Division (the Big Red One) that landed on Omaha Beach on D-Day.

At the harbour entrance stands the mighty Nothe Fort, surrounded by its attractive gardens, like a green moat.

Nothe Gardens, with their uninterrupted sea views, are one of the many jewels in Weymouth's crown, and played host to tens of thousands of spectators who came to watch the dramatic Olympic sailing events of 2012.

Passing Greenhill with its delightful gardens and colourful beach huts, the mile-long shingle of Preston Beach reminds me of Chesil, until reaching Overcombe Corner, a popular gathering spot for watersports fans.

The coastline now becomes a four-mile stretch of low and gradually-eroding cliffs, until it reaches the great chalk headland of the Gallic-looking White Nothe, marking the eastern end of the bay and the beginning of Purbeck.

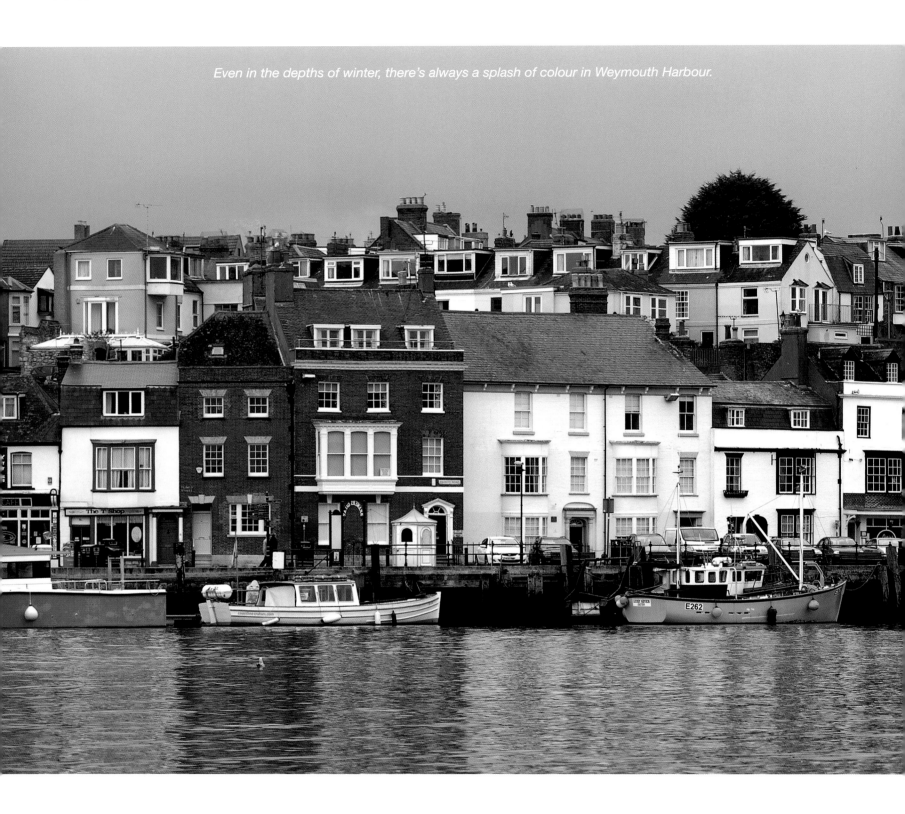

Even in the depths of winter, there's always a splash of colour in Weymouth Harbour.

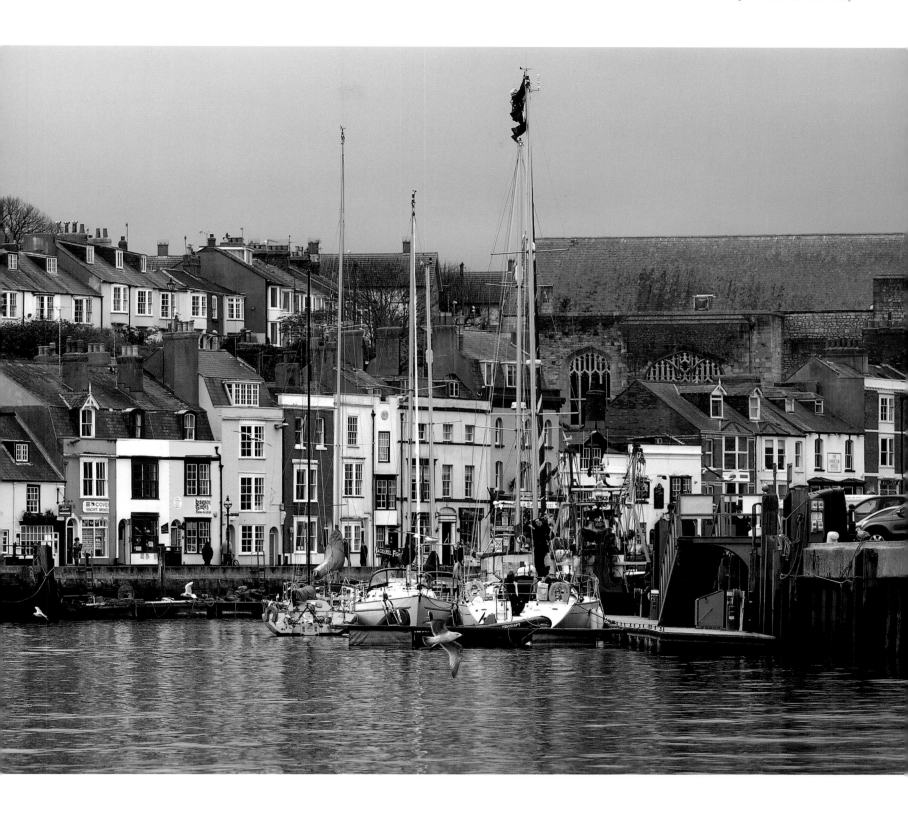

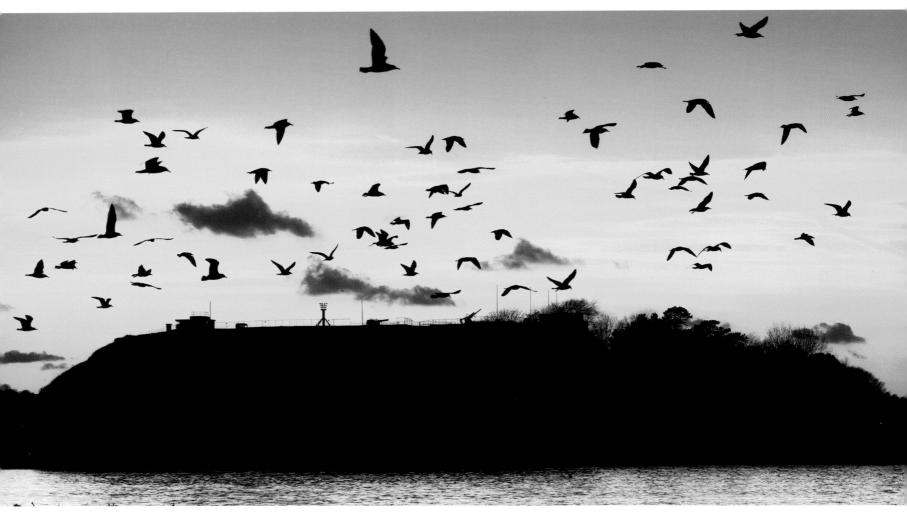

A flock of gulls heads past Nothe Fort on a winter evening.

Opposite, top: Nothe Fort and gardens in January enjoy lovely afternoon sunshine.

In October, the beach gets put to good use with the annual Motocross Festival. Organised by the town's Lions Club, it always attracts large crowds, and generates plenty of cash for charity.

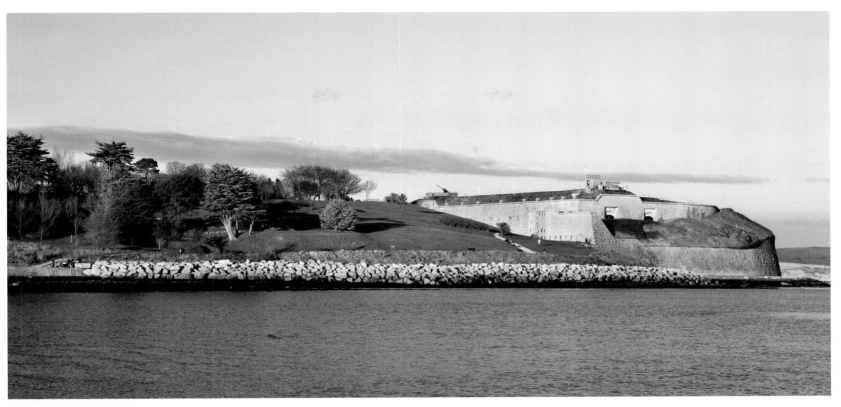

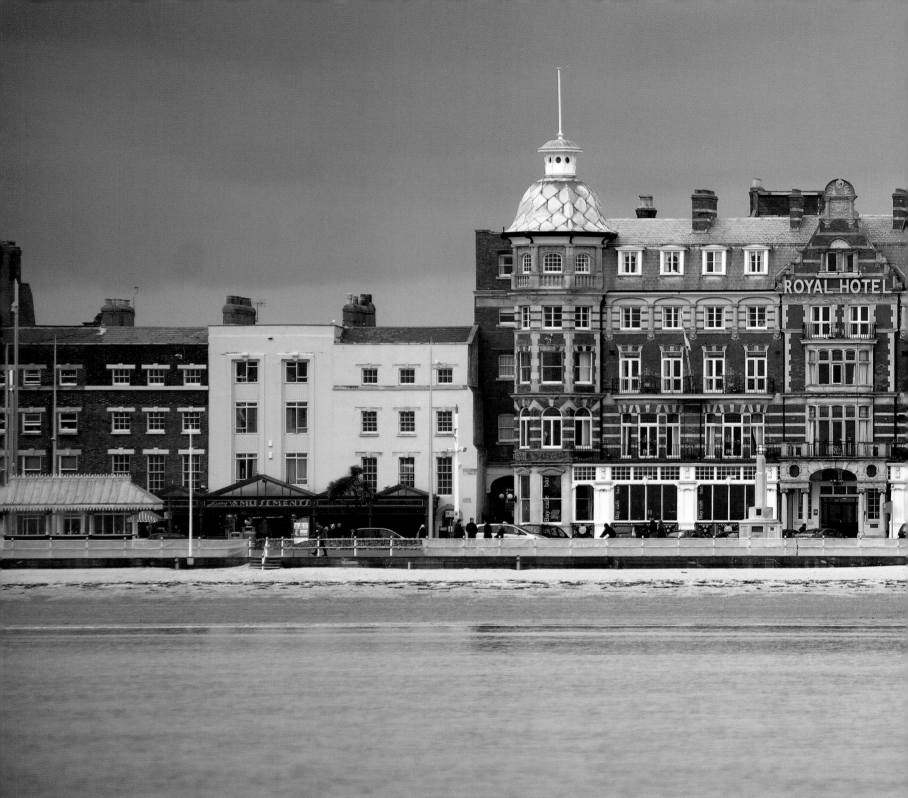

The regal splendour of the Georgian Esplanade in winter, dominated by the Royal Gloucester Hotel. It was built by the eponymous duke for his brother, King George the Third, to stay in during his many visits to the town.

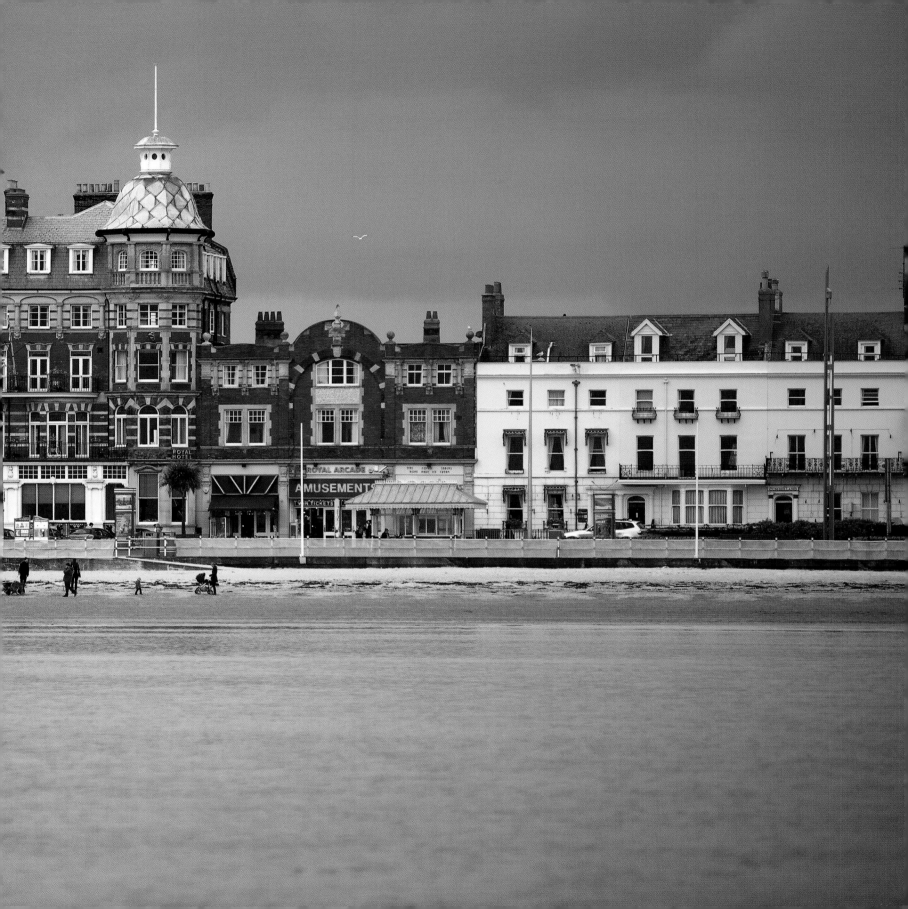

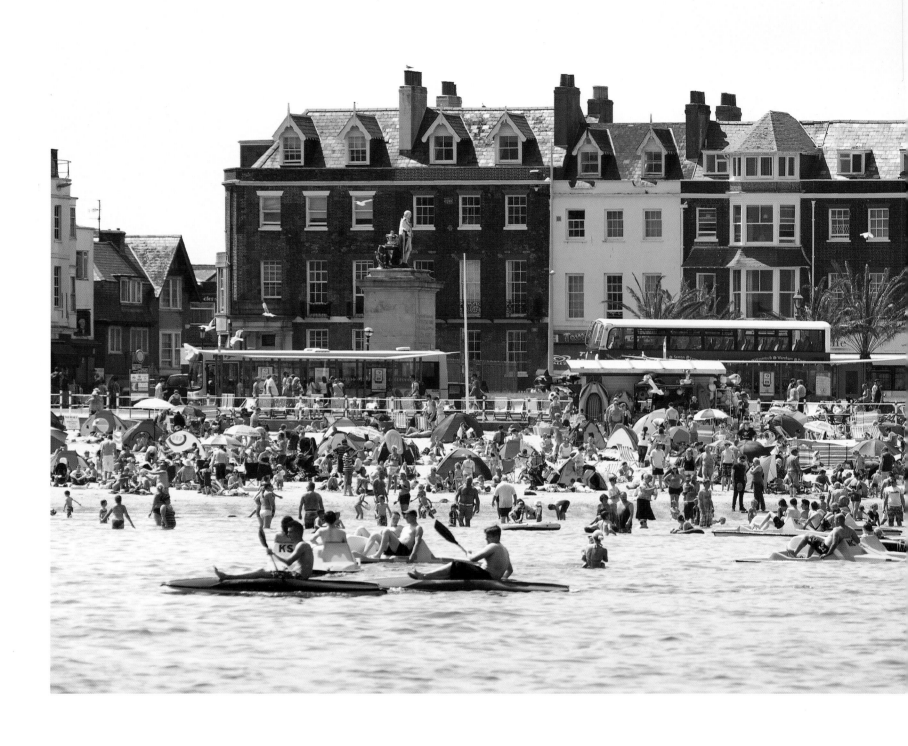

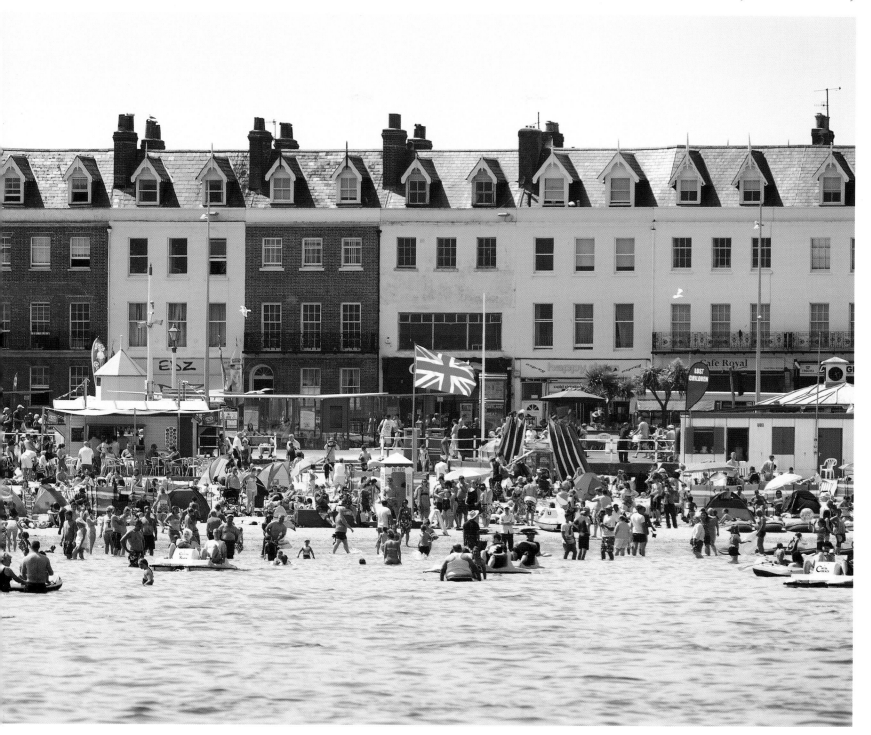

Weymouth doing what it does best. The popular beach is regarded as one of the cleanest and safest in the country. It is pictured here in early July, BEFORE the school summer holidays ...

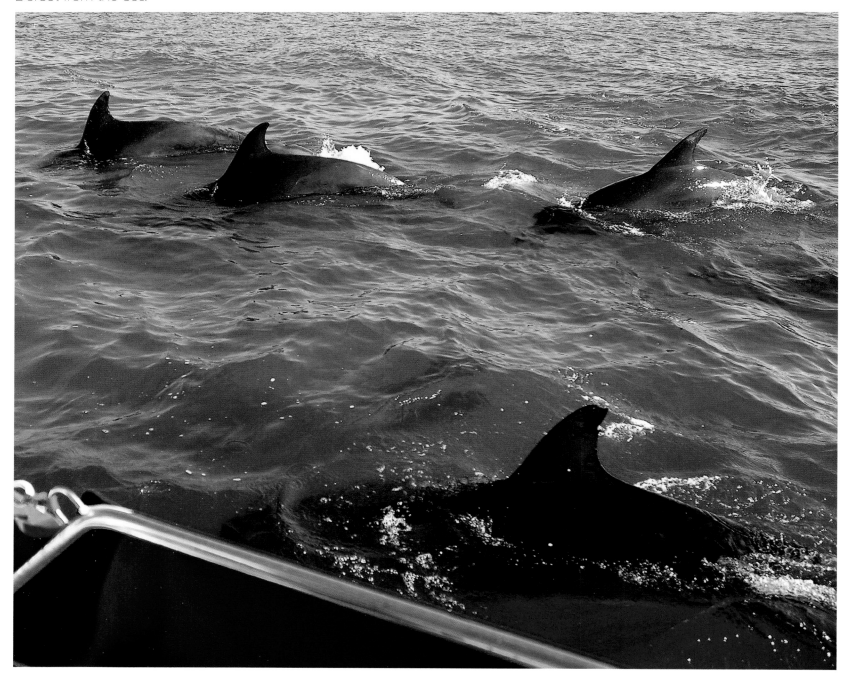

A pod of bottle-nose dolphins plays around the boat in Weymouth Bay.

Opposite: Extraordinary clouds created by Portland. Moist air coming across the Channel is forced upwards when it hits the island, and condenses into unusual cloud formations.

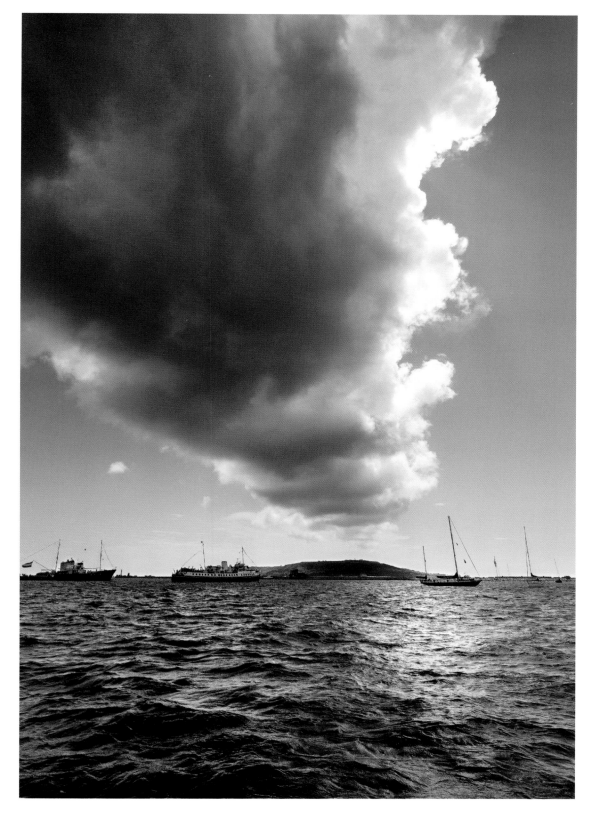

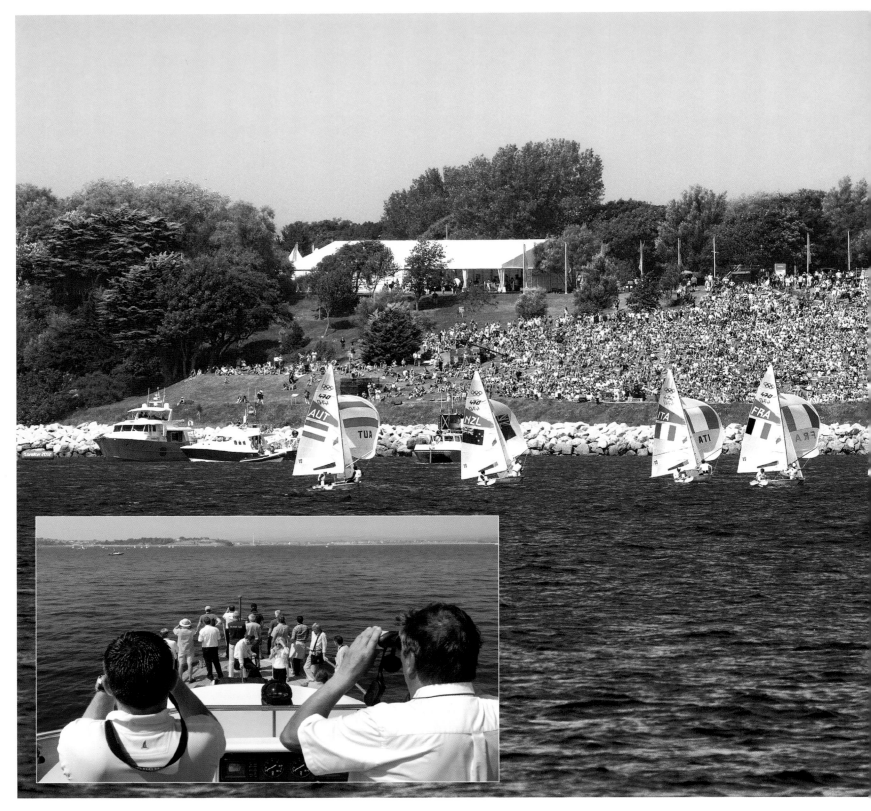

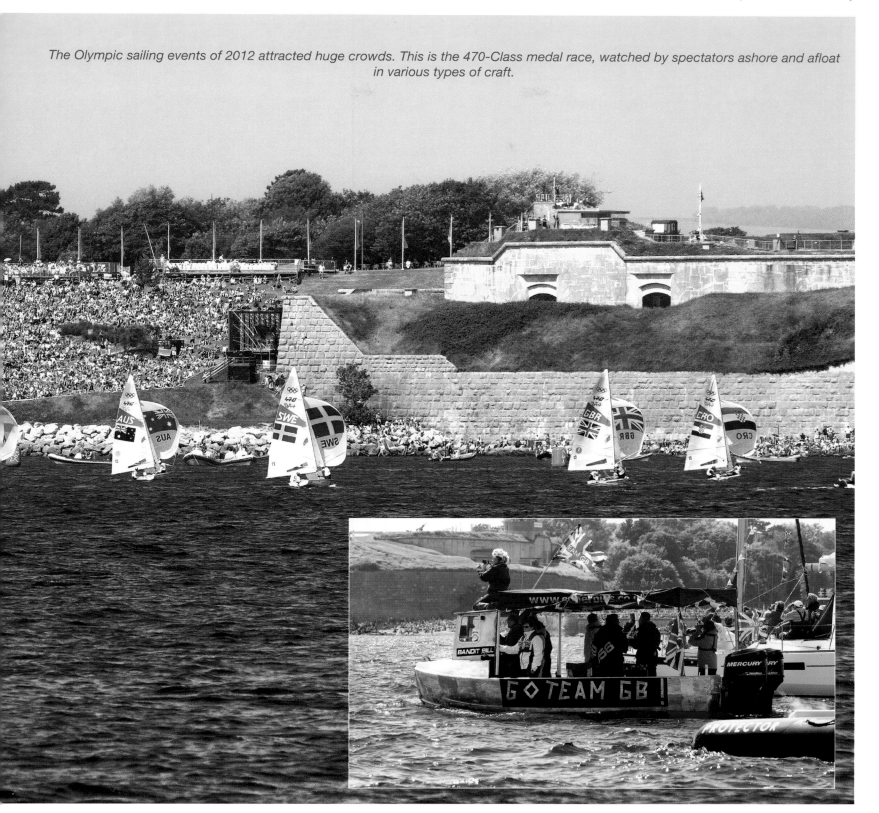

The Olympic sailing events of 2012 attracted huge crowds. This is the 470-Class medal race, watched by spectators ashore and afloat in various types of craft.

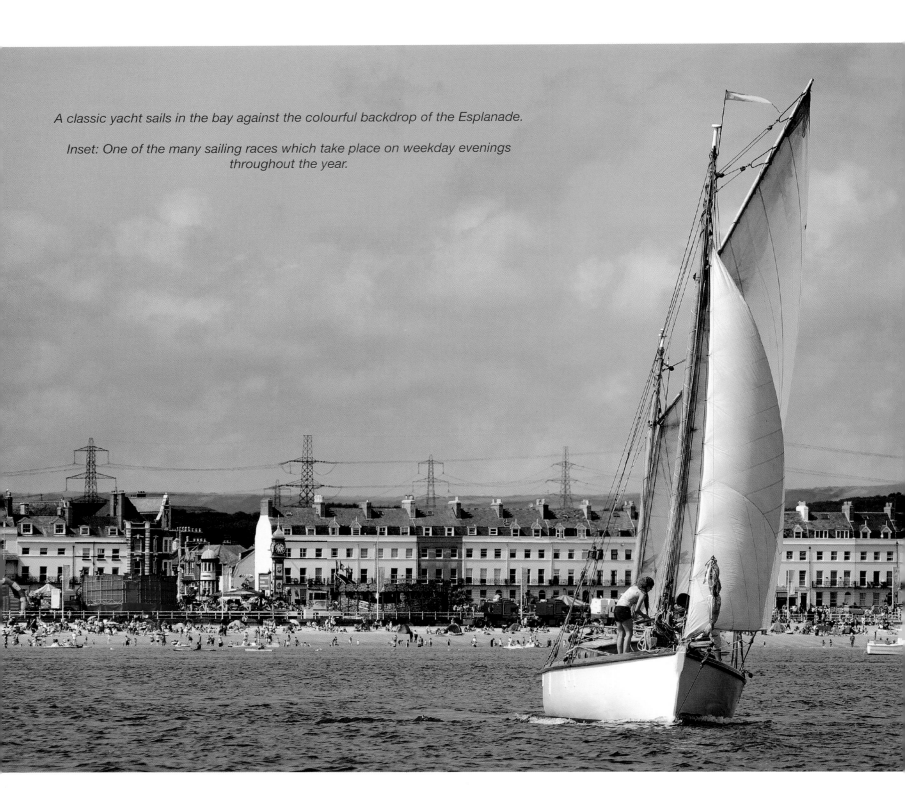

A classic yacht sails in the bay against the colourful backdrop of the Esplanade.

Inset: One of the many sailing races which take place on weekday evenings throughout the year.

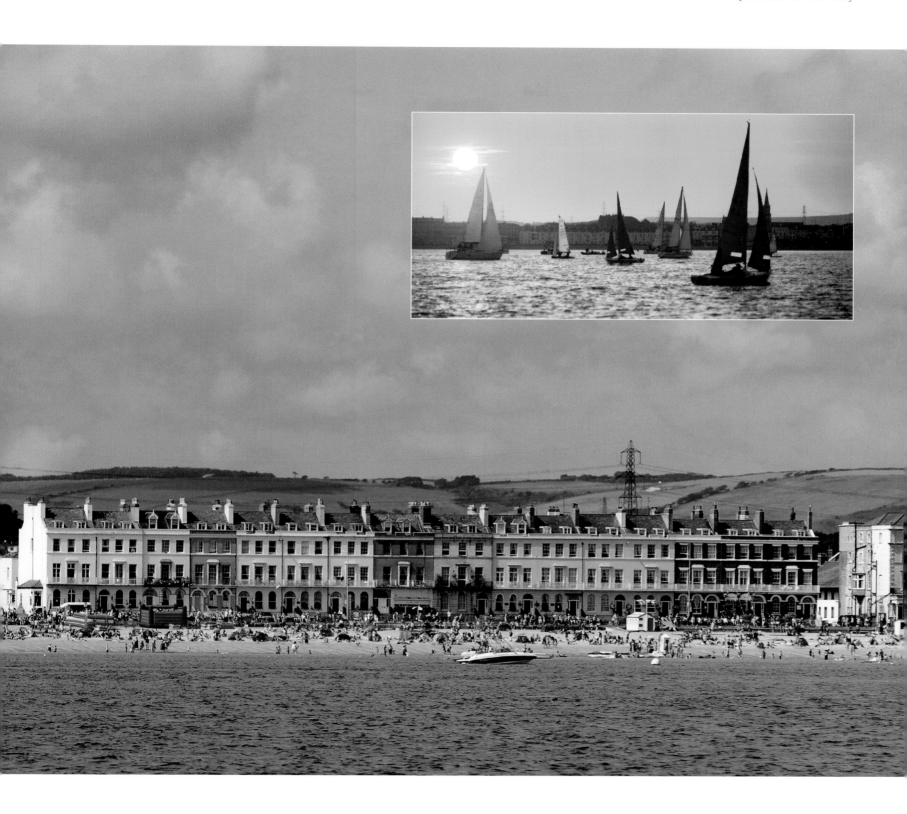

The handsome steam ship Balmoral is a frequent visitor to Weymouth, taking passengers on day excursions along the coast. The white horse rider on the hill near Osmington is George III, who, as a frequent visitor, was responsible for Weymouth's popularity. However, legend has it that the king was 'most displeased' that the great carving depicted him riding away from the town.

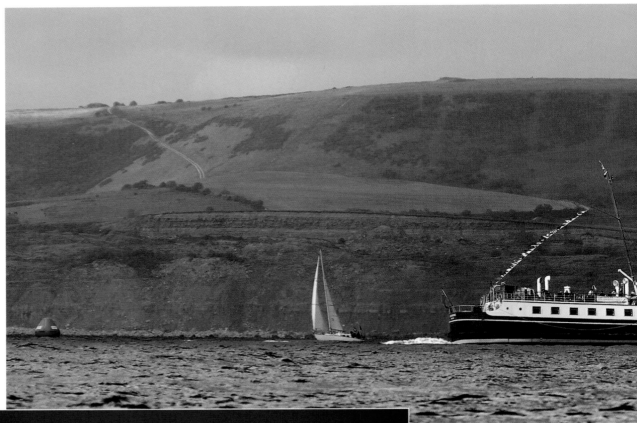

The bay is a popular anchorage for ships at all times of the year.

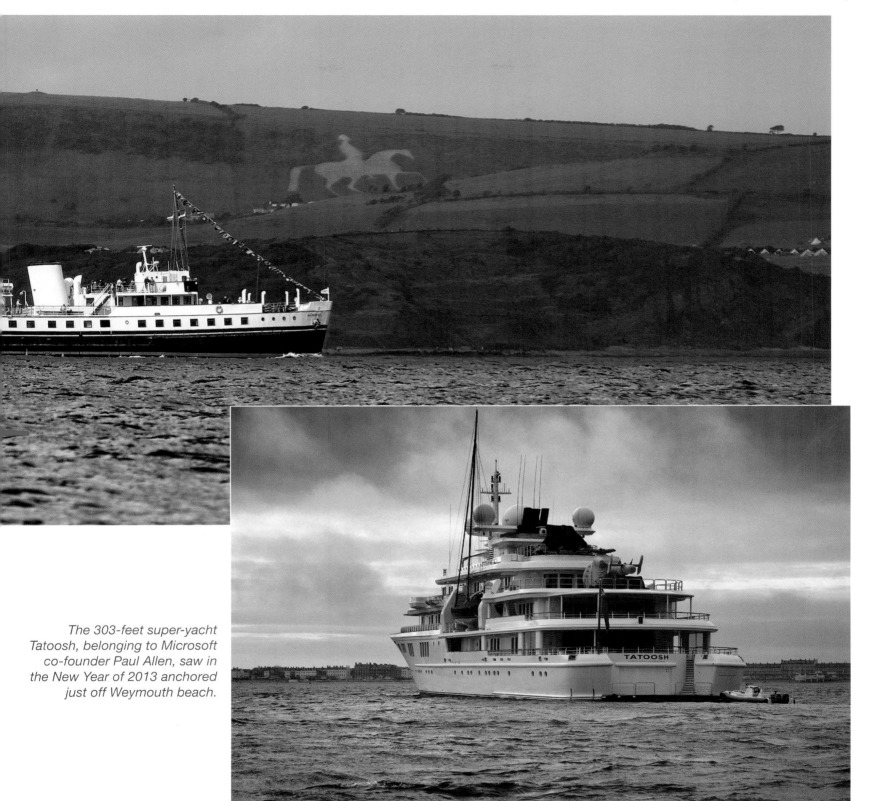

The 303-feet super-yacht Tatoosh, belonging to Microsoft co-founder Paul Allen, saw in the New Year of 2013 anchored just off Weymouth beach.

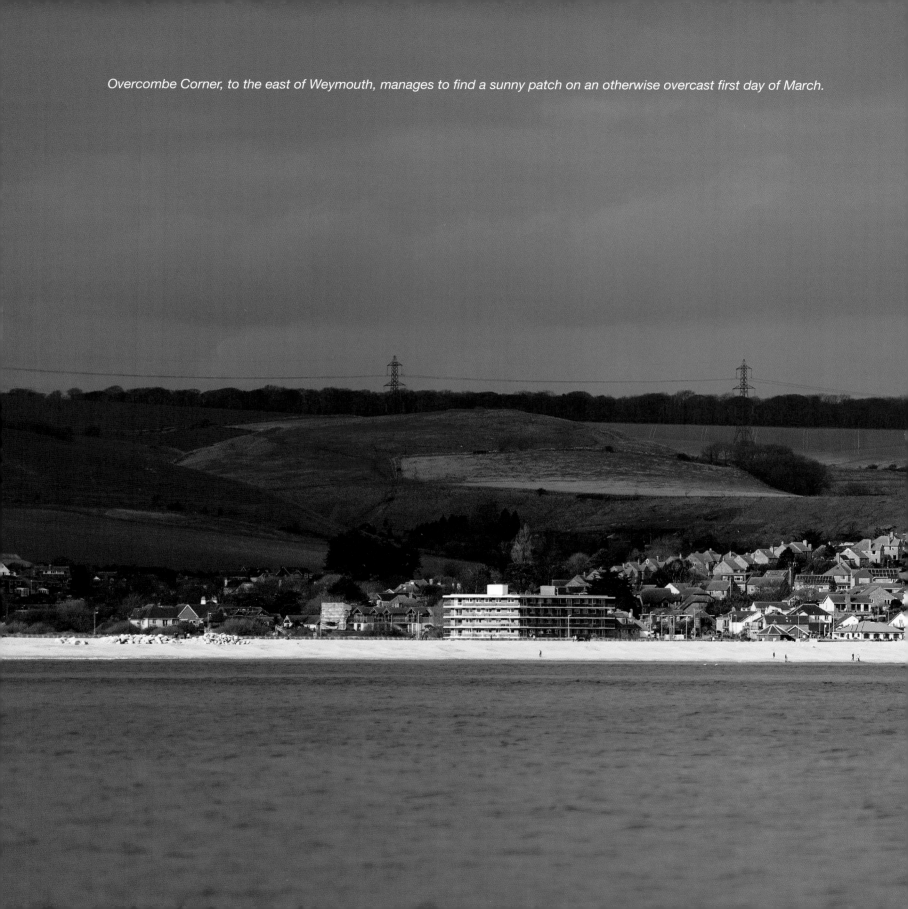

Overcombe Corner, to the east of Weymouth, manages to find a sunny patch on an otherwise overcast first day of March.

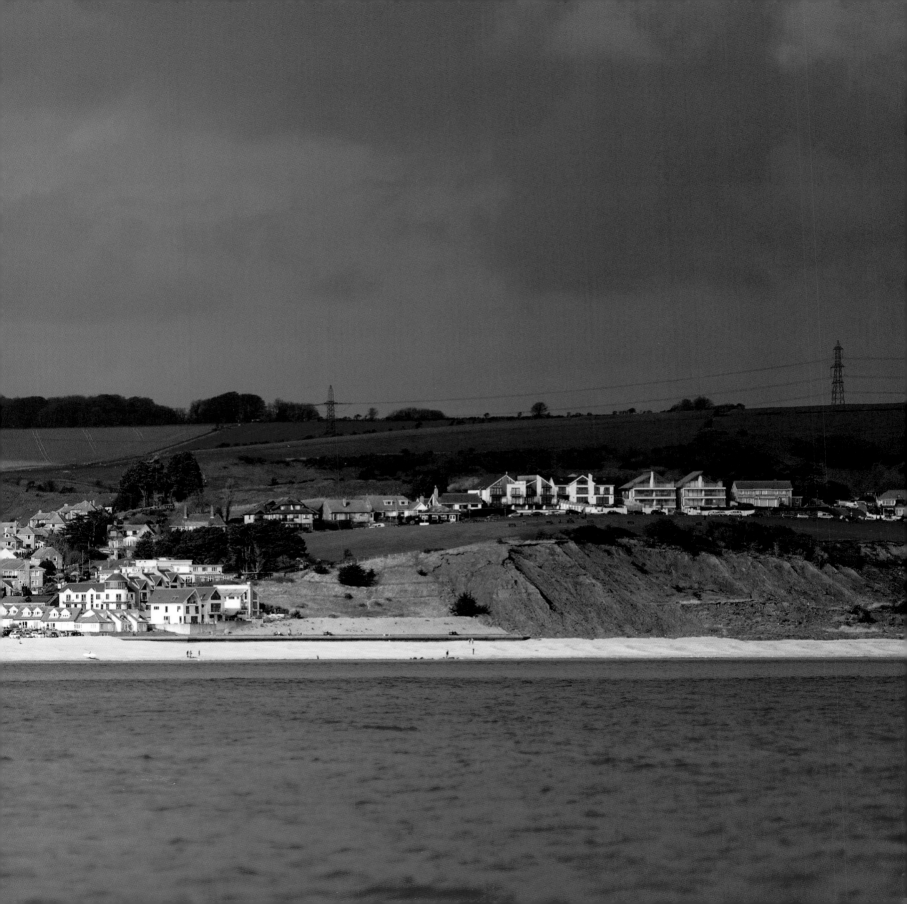

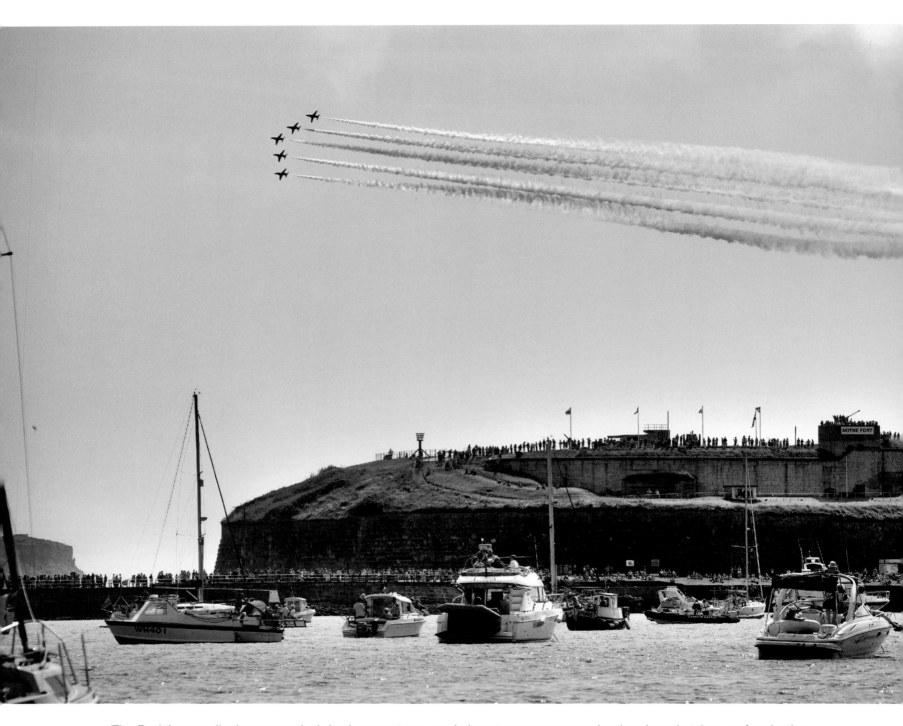

The Red Arrows display on carnival day is a must-see, and almost every space on land and sea is taken up for viewing.

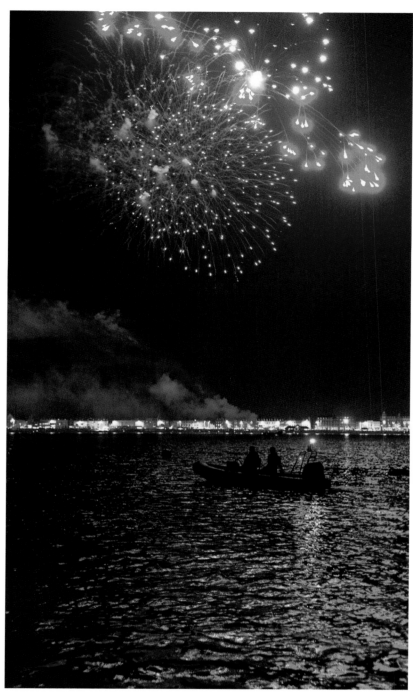

End-of-summer fireworks.

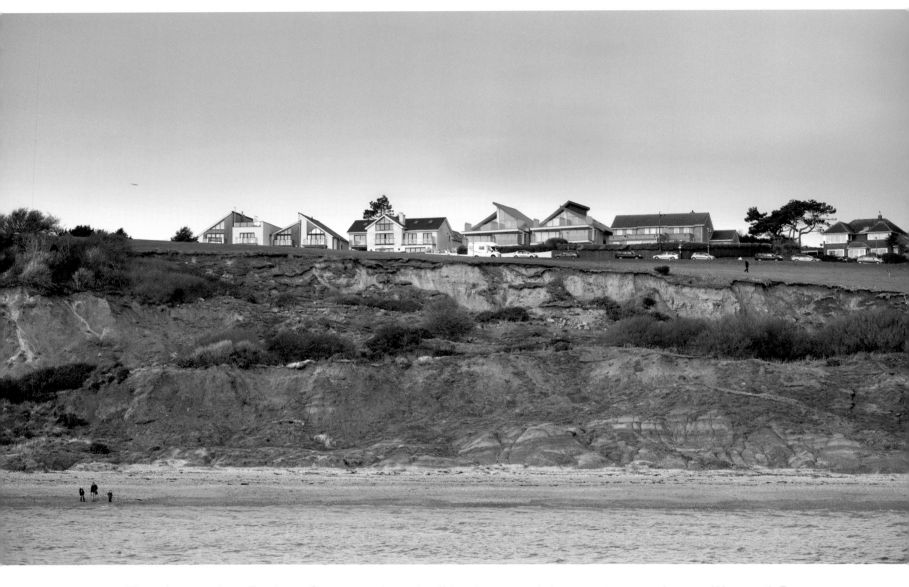

*These houses along Bowleaze Coveway enjoy splendid, uninterrupted views out to sea and across Weymouth Bay.
Landslip activity can be seen along Furzy Cliff.*

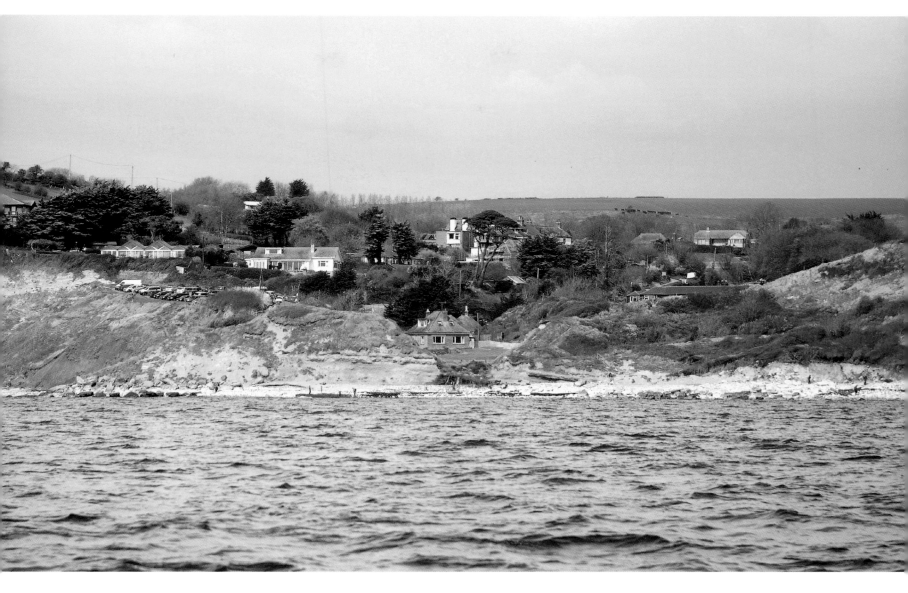

The coastal hamlet of Osmington Mills has a 'colourful' past, and the splendid Smugglers Inn is so-named for a reason!
In the early 19th century, the artist John Constable spent his honeymoon in the area, and painted several of his seascapes here.

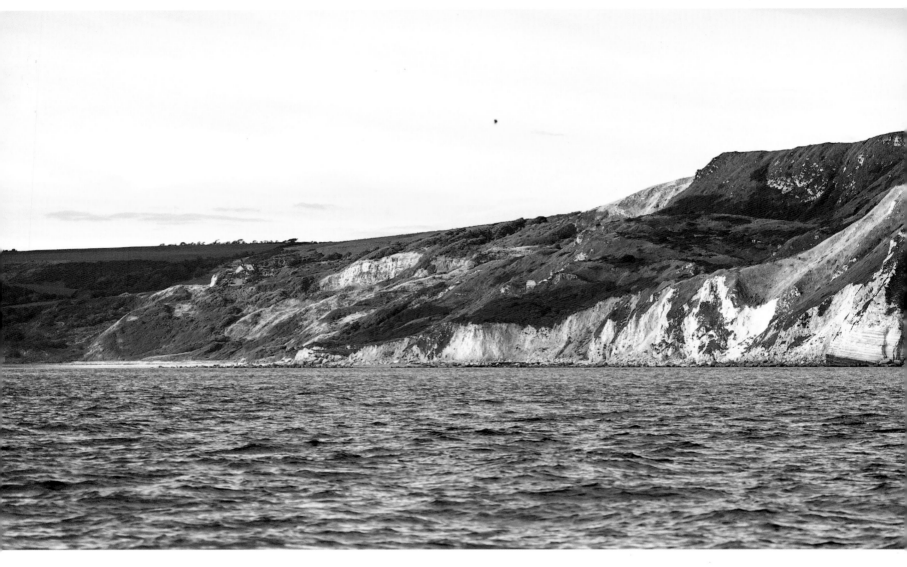

The dramatic, 160-metre chalk headland of White Nothe marks the eastern end of Ringstead Bay and the start of Purbeck. To the left is the Burning Cliff, which, from 1826, smouldered with an underground fire for several years due to its oil shale combusting. Further left is Ringstead beach.

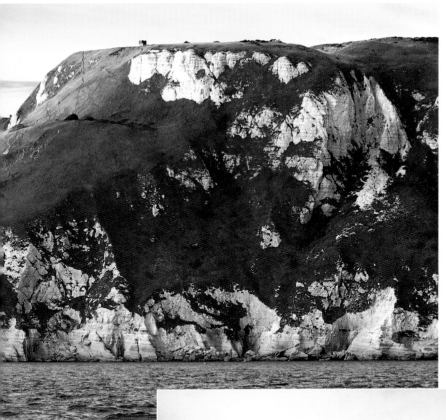

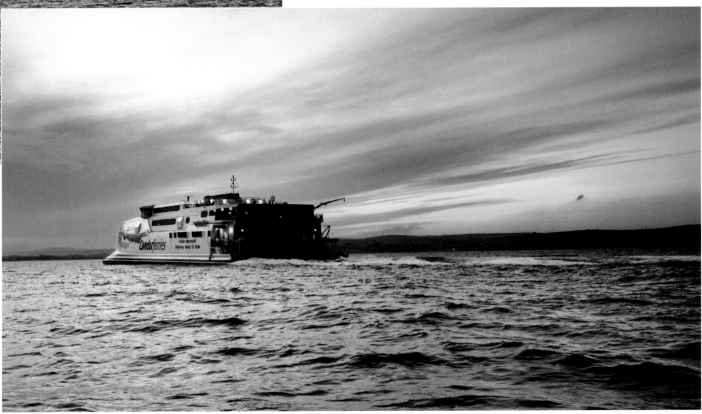

Condor Ferries' Vitesse returns to Weymouth Harbour from Guernsey.

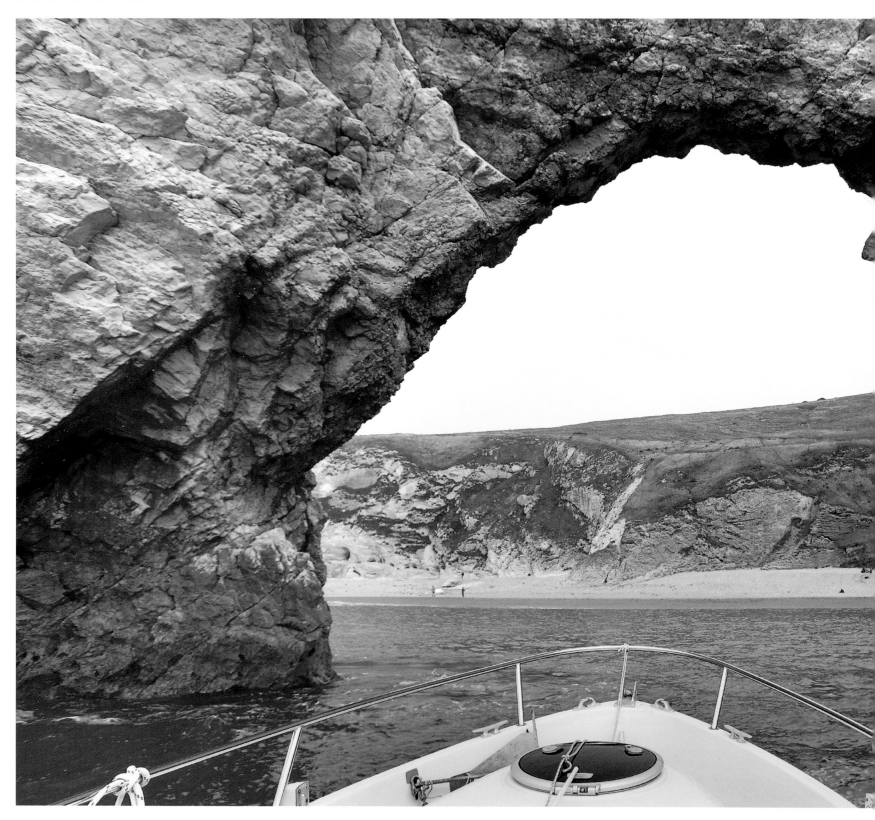

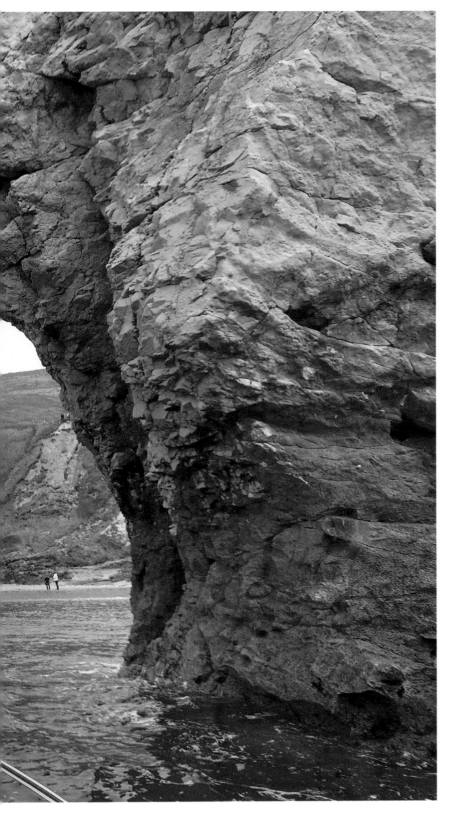

Durdle Door is often thought of as the start of Purbeck, but the district actually begins at White Nothe a little earlier in our journey. Navigating through the narrow Door is not for the faint-hearted, but local boaters will occasionally take their vessels through just for the thrill ...

Purbeck

The Jurassic Coast through Purbeck is studded with famous features – Durdle Door, Lulworth Cove, and the dark oil-shale of Kimmeridge.

The chalk cliffs of the western end transition to a variety of clays, chalk and limestone, before the Cretaceous chalk dominates again at the Handfast Peninsula, with the pinnacles of Old Harry Rocks.

It's always a pleasure to potter close to the shore, past small headlands, large promontories, and coves, many prosaically named, like Dungy Head, Bacon Hole, Brandy Bay, Clavell's Landing.

The pretty 'breach' of Lulworth Cove is popular, but a mile or so on there's a much bigger one: Worbarrow Bay. Tricky to get to by land, visitors are few, and it's a beautiful, relaxing spot, backed by towering Bindon Hill and the colourful but collapsing Flowers Barrow hill fort.

Leaving Worbarrow, the mighty Gad Cliff comes into view, and, further, the oil-shale of Kimmeridge can look bleak on all but the sunniest days.

Swyre and St Alban's (properly St Aldhelm's) Heads beckon you to look 'round the corner' toward the eastern end of the Jurassic Coast.

This is a changing landscape (natural and human activity), a man-modified and hand-hewn waterfront, where the hard and unforgiving Purbeck limestone and marble have been quarried.

The cliffs are low but sheer, with great, cube-shaped slabs at the water's edge, and huge, symmetrical gouges where boats used to collect their heavy loads.

Caves and holes pepper the coast, and splashes of colour are provided by climbers, canoeists and coasteerers, not to mention the aerial antics of guillemots, razor bills, puffin, shag and fulmar.

The headlands of Anvil Point and Durlston give way to shallow Swanage Bay, before the chalk rise of Ballard Down and the Handfast Peninsula signify the eastern, and youngest, end of the Jurassic Coast.

Our journey ends here, but the tale's not quite over. The dazzling white cliffs and stacks of the peninsula (better known as Old Harry and his family) resurface some seven miles further east as his distant relatives, the Isle of Wight's famous Needles. But that's another story, and another journey ...

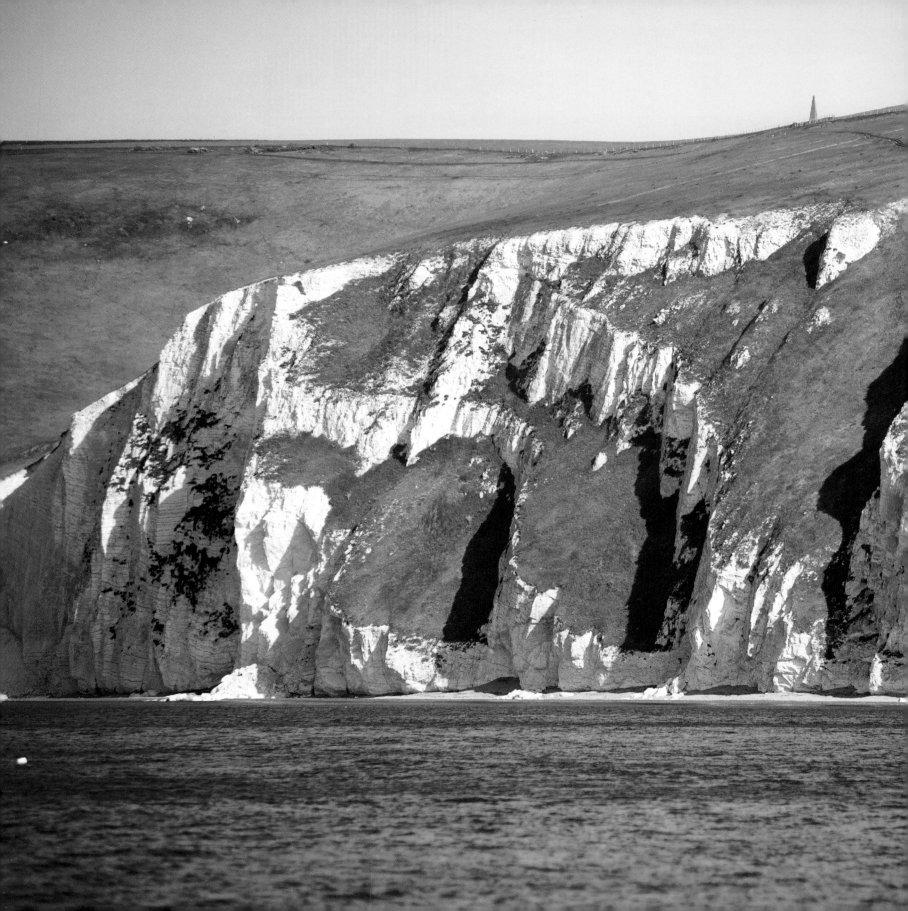

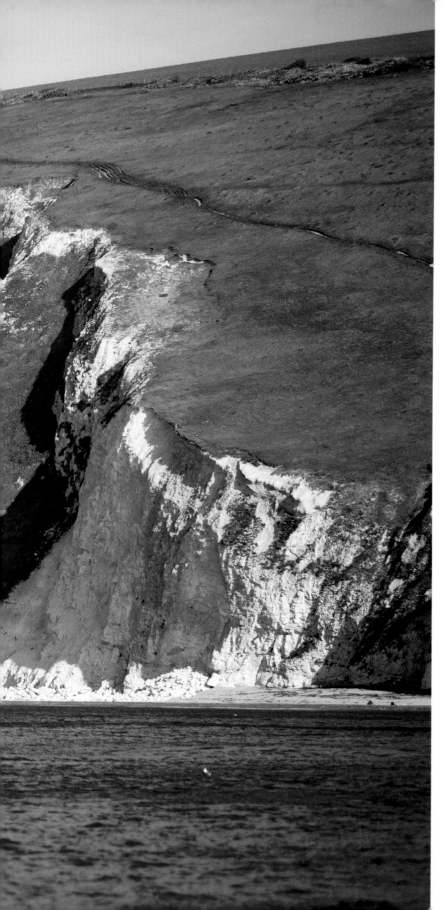

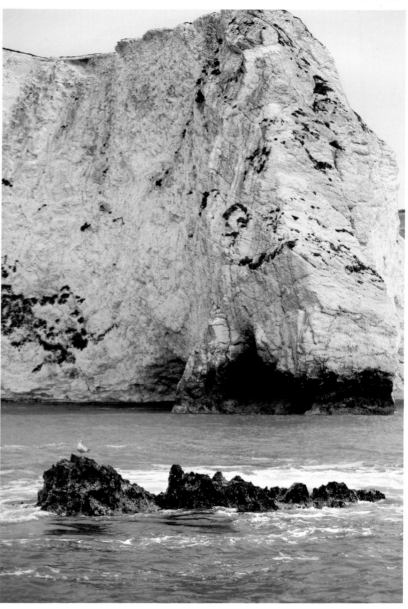

There are several sinister rocks lying just off this stretch of coast waiting to catch out the unwary sailor. This is The Cow, which lurks just off Bat's Head.

On the eastern side of the White Nothe headland lie a series of small, almost inaccessible beaches. This is West Bottom.
At the top of the striated chalk cliff is a conspicuous sea-mark, thought by many to be for navigation purposes. The beacon, and its twin further inland, were actually constructed as sighting marks to test the accuracy of gunners in the Victorian navy.

Right: Durdle Door needs little introduction. It's one of the most photographed Dorset landmarks, though few people are privileged to enjoy this aspect from seaward, on a warm May evening.

Part of the Lulworth Crumple is located in Man o' War cove, on the east side of the Durdle Door promontory.

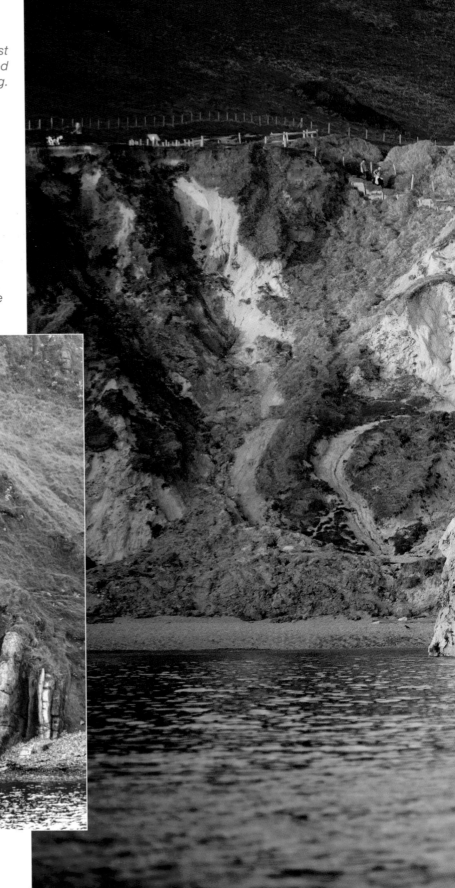

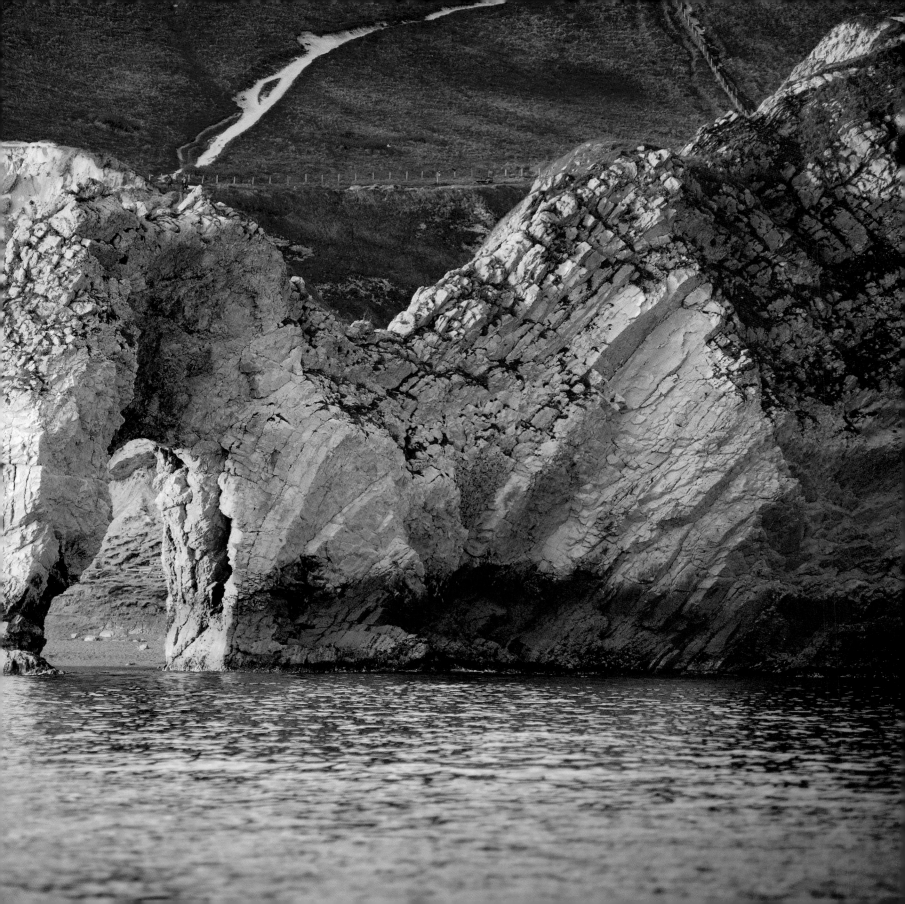

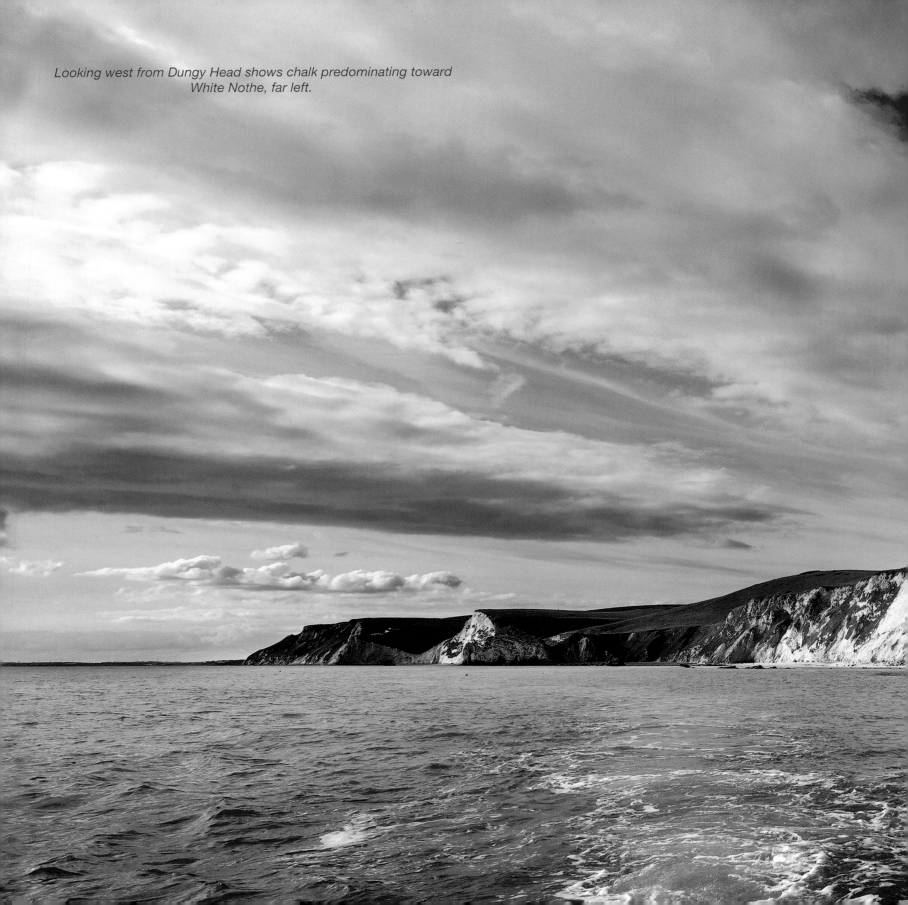

Looking west from Dungy Head shows chalk predominating toward White Nothe, far left.

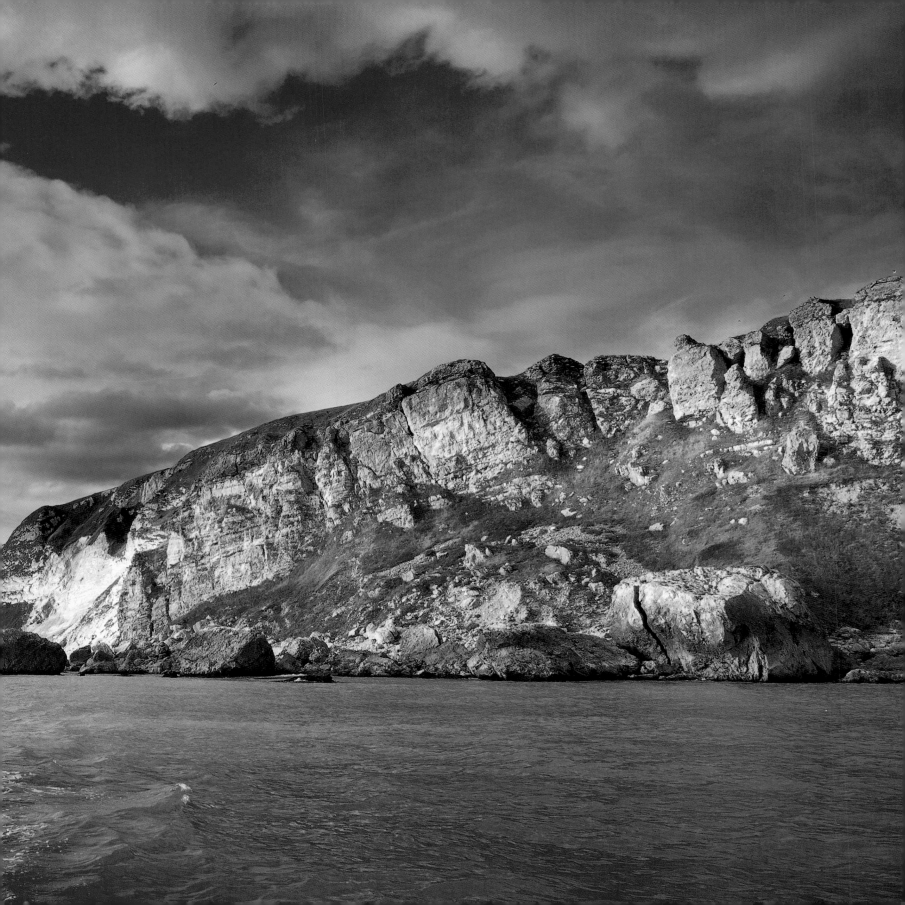

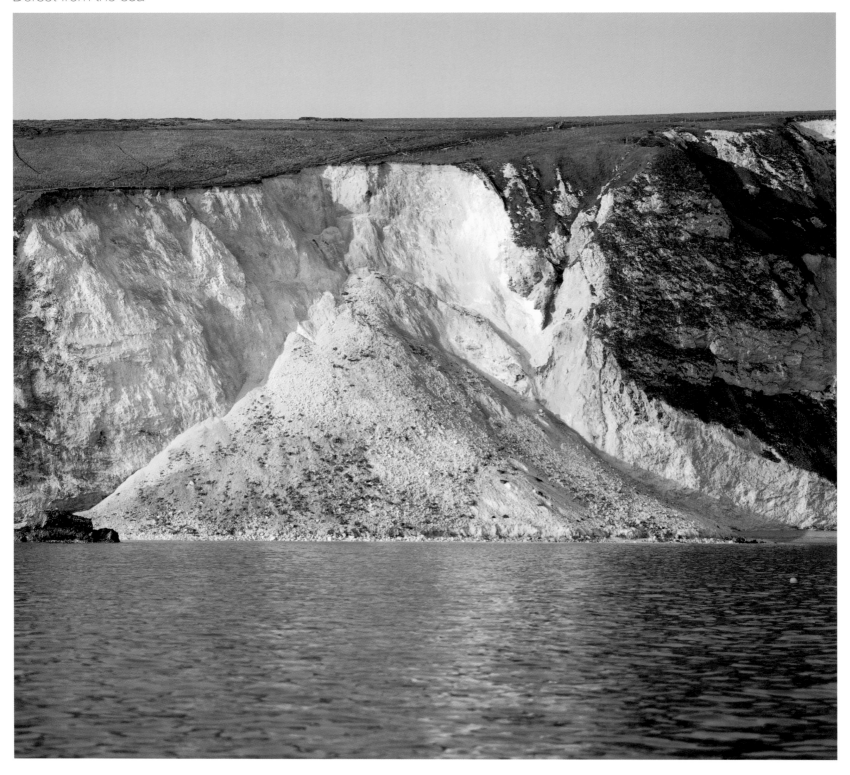

Regular cliff falls remind us of the constantly eroding and evolving Jurassic Coastline. This big one, at St Oswald's Bay in 2013, took some of the coast path with it, and made the national newspapers. Less than a year later the fall had been washed away by the winter storms.

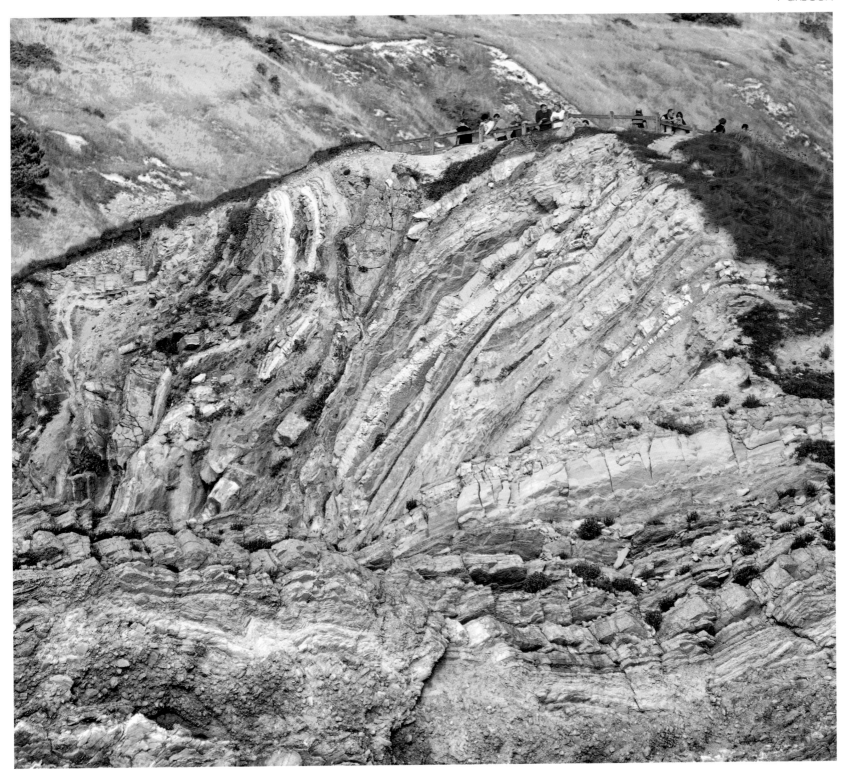

The Lulworth Crumple, next door to the Cove, shows amazing, distorted strata, particularly from seaward. This is limestone folding caused when Africa and Europe collided a long time ago; a collision which also formed the Alps.

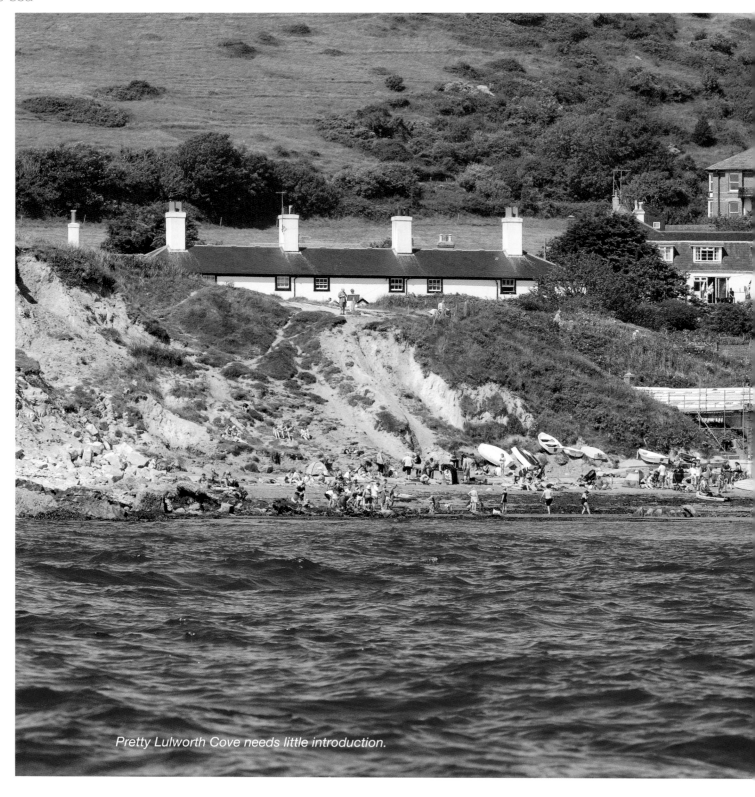

Pretty Lulworth Cove needs little introduction.

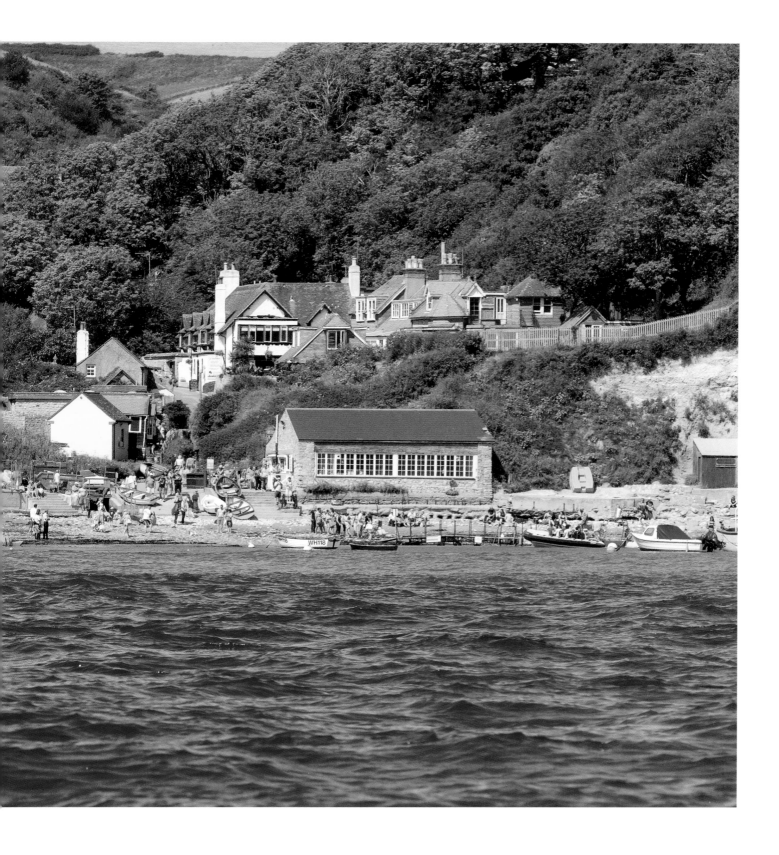

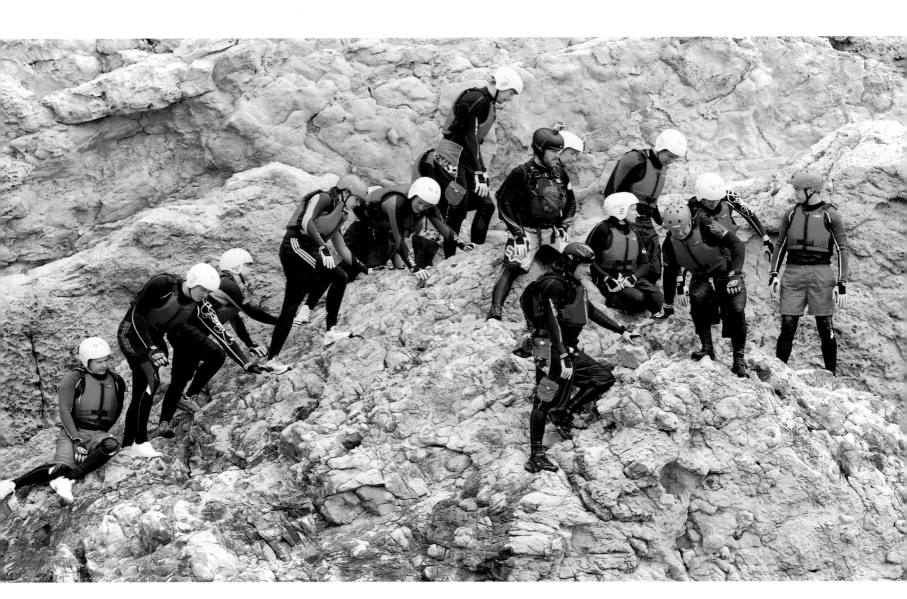

The sport of coasteering is becoming increasingly popular. Here, a group of enthusiasts hone their skills near Durdle Door.

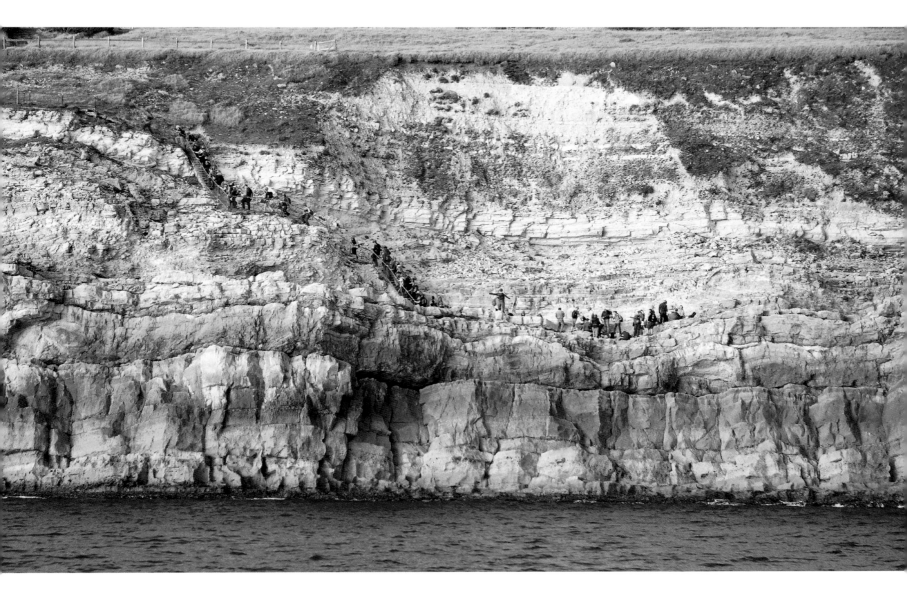

Geology students on a field trip scale the South Cliff, near the fossil forest at Lulworth.

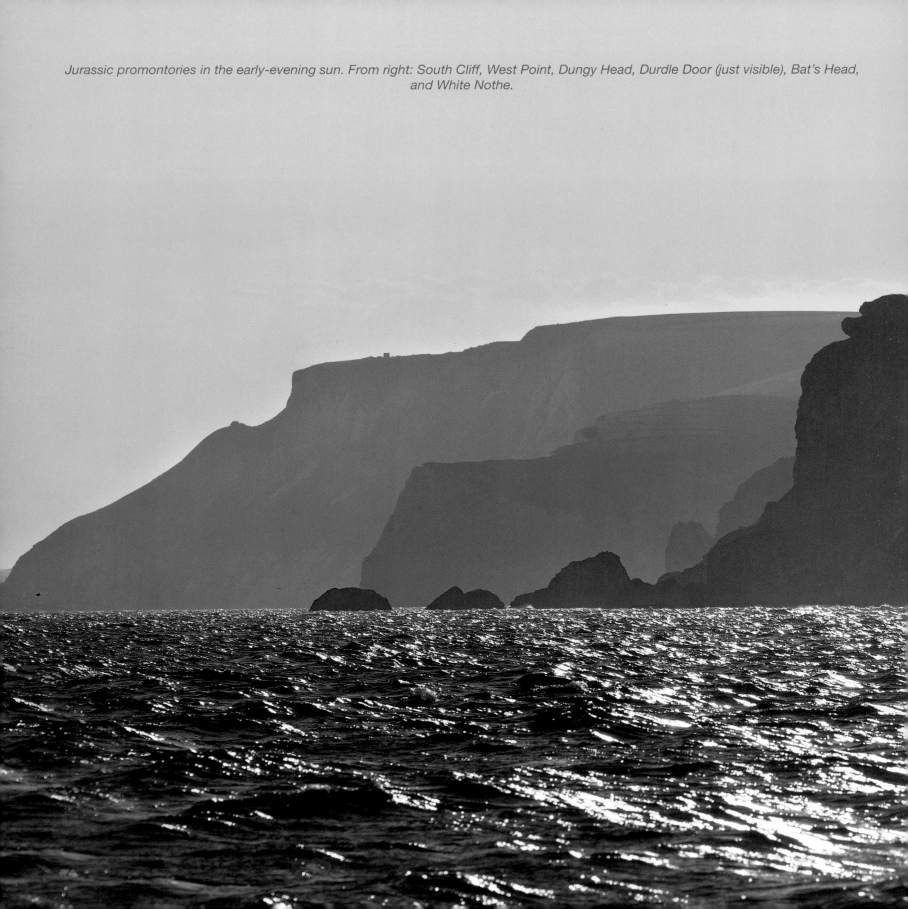

Jurassic promontories in the early-evening sun. From right: South Cliff, West Point, Dungy Head, Durdle Door (just visible), Bat's Head, and White Nothe.

Main pic: In particular lighting conditions, dazzling colours leap out from the rock formations around Worbarrow Bay.

Lower, right: Beautiful Worbarrow is dominated at its eastern end by Flowers Barrow, an imposing Iron Age hill fort which is rapidly collapsing into the sea.

Below: Mupe Bay at dawn. The western end of the greater Worbarrow Bay is, understandably, a popular anchorage with boaters.

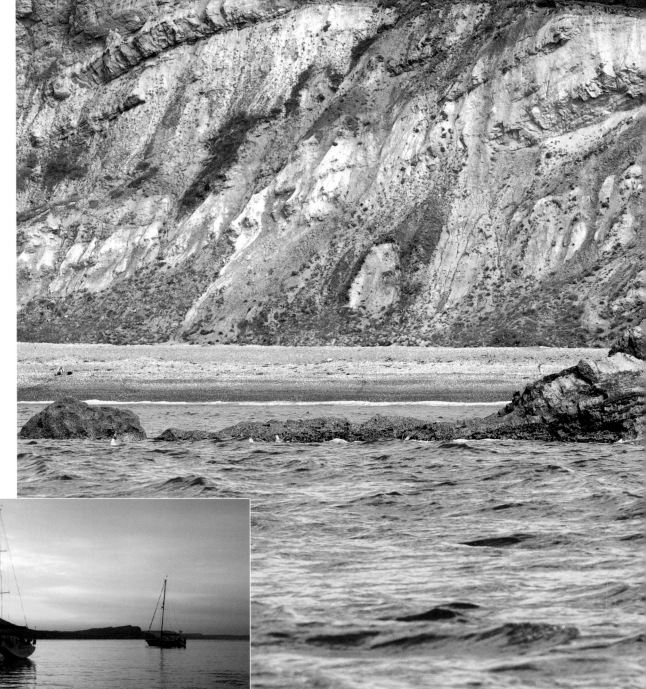

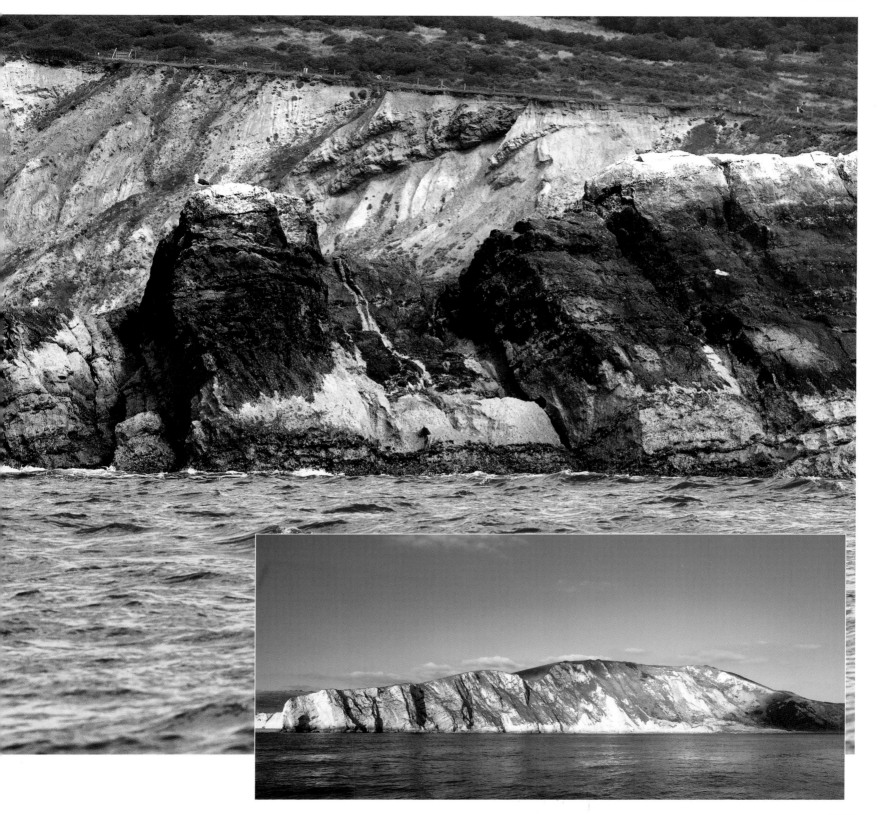

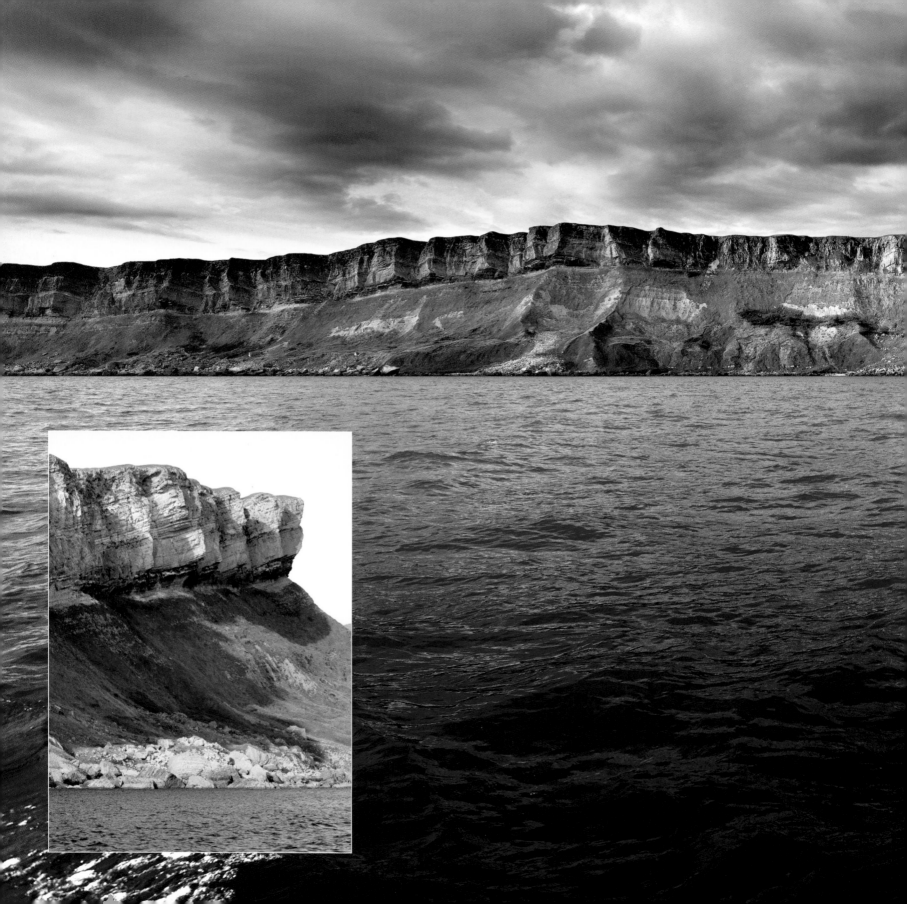

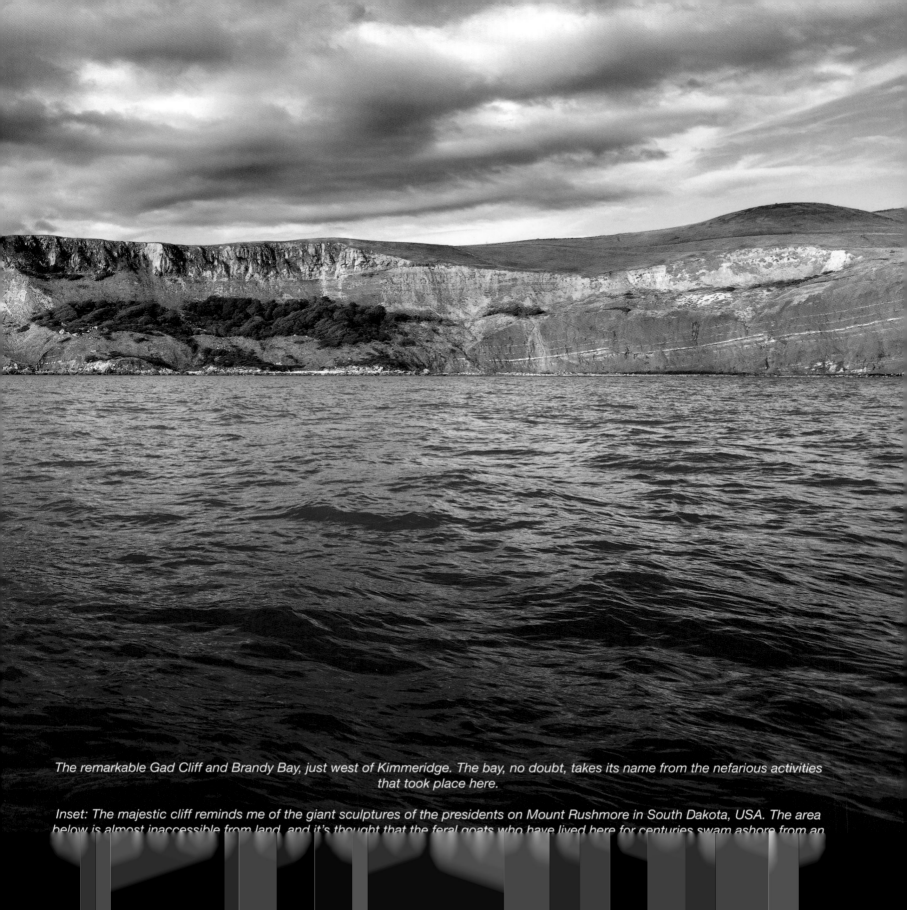

The remarkable Gad Cliff and Brandy Bay, just west of Kimmeridge. The bay, no doubt, takes its name from the nefarious activities that took place here.

Inset: The majestic cliff reminds me of the giant sculptures of the presidents on Mount Rushmore in South Dakota, USA. The area below is almost inaccessible from land, and it's thought that the feral goats who have lived here for centuries swam ashore from an

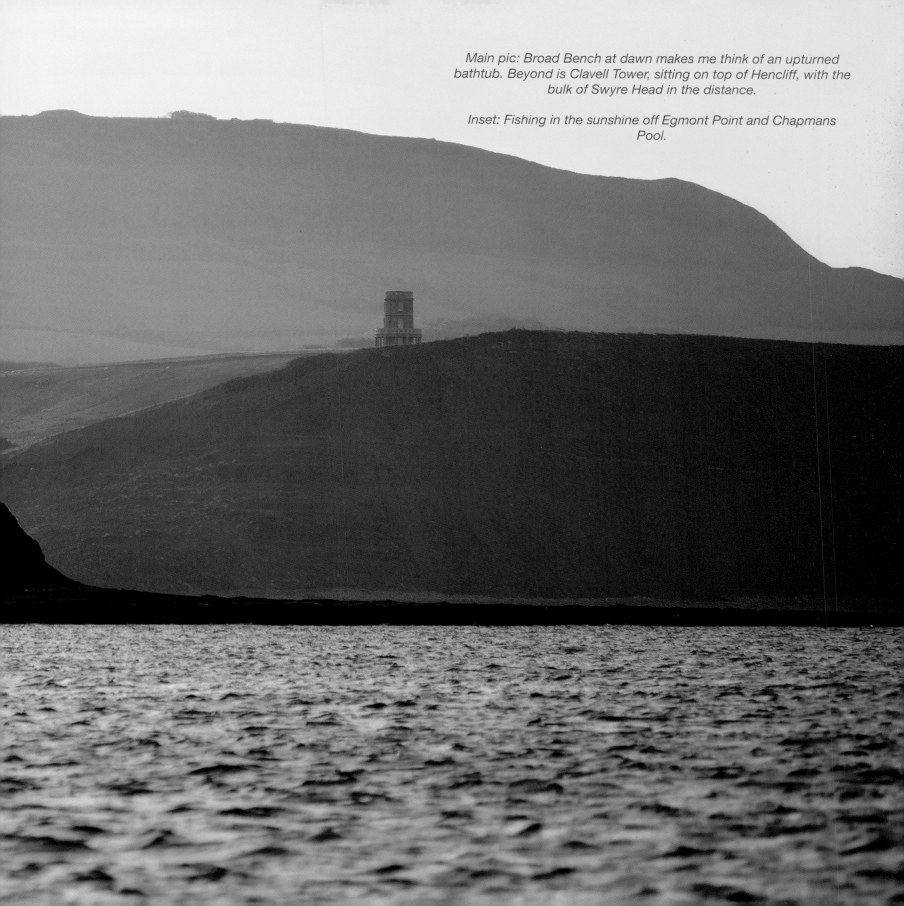

Main pic: Broad Bench at dawn makes me think of an upturned bathtub. Beyond is Clavell Tower, sitting on top of Hencliff, with the bulk of Swyre Head in the distance.

Inset: Fishing in the sunshine off Egmont Point and Chapmans Pool.

The austere, 108-metre-high St Alban's (properly St Aldhelm's) Head is rightly feared by sailors in bad weather, but becomes a verdant joy in July sunshine.
It was originally named after St Aldhelm, who visited the headland in the 8th century on his way south to confer with the Pope.

St Alban's Head, right, and Emmetts Hill, under a striking October sky.

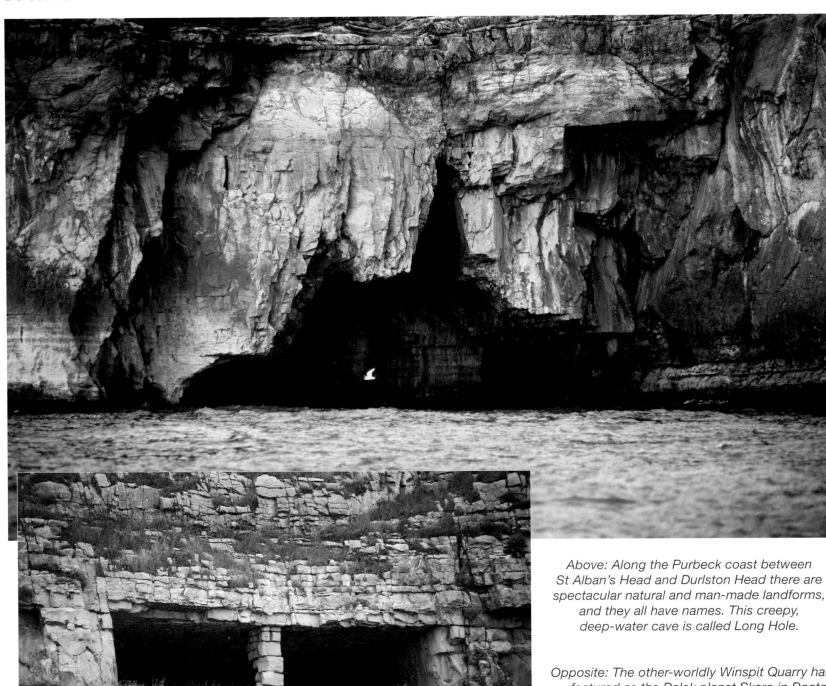

Above: Along the Purbeck coast between St Alban's Head and Durlston Head there are spectacular natural and man-made landforms, and they all have names. This creepy, deep-water cave is called Long Hole.

Opposite: The other-worldly Winspit Quarry has featured as the Dalek planet Skaro in Doctor Who, and was revisited by the BBC as planet Mecron II in the cult series Blake's 7.

Quarried galleries in the Purbeck stone stare out like spooky eyes.

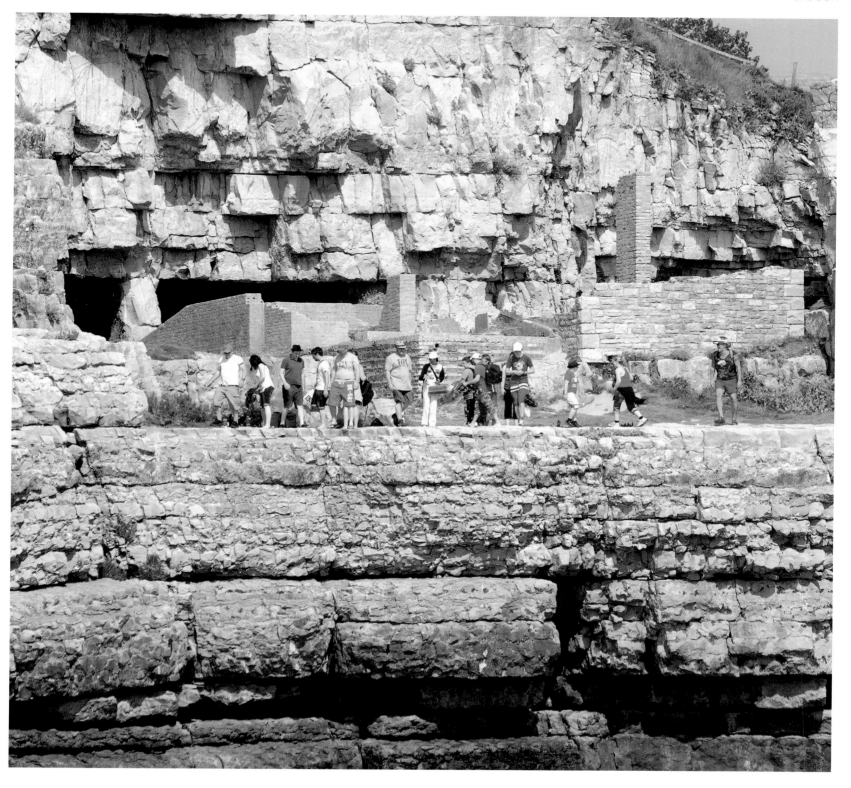

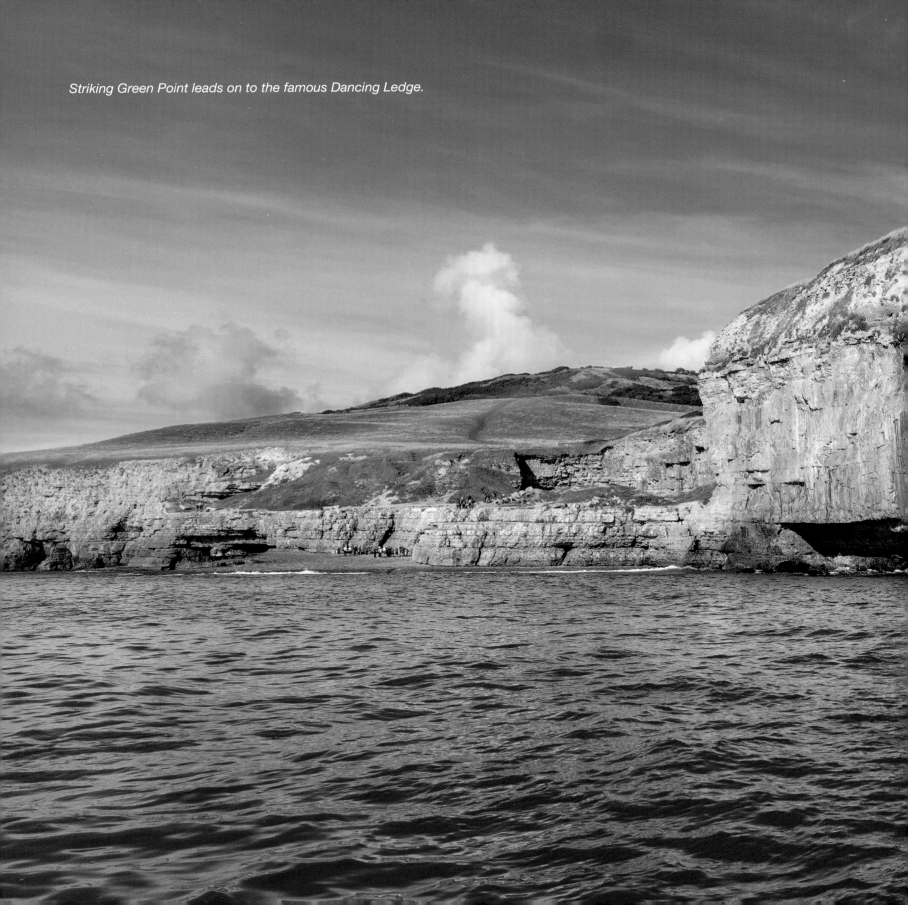

Striking Green Point leads on to the famous Dancing Ledge.

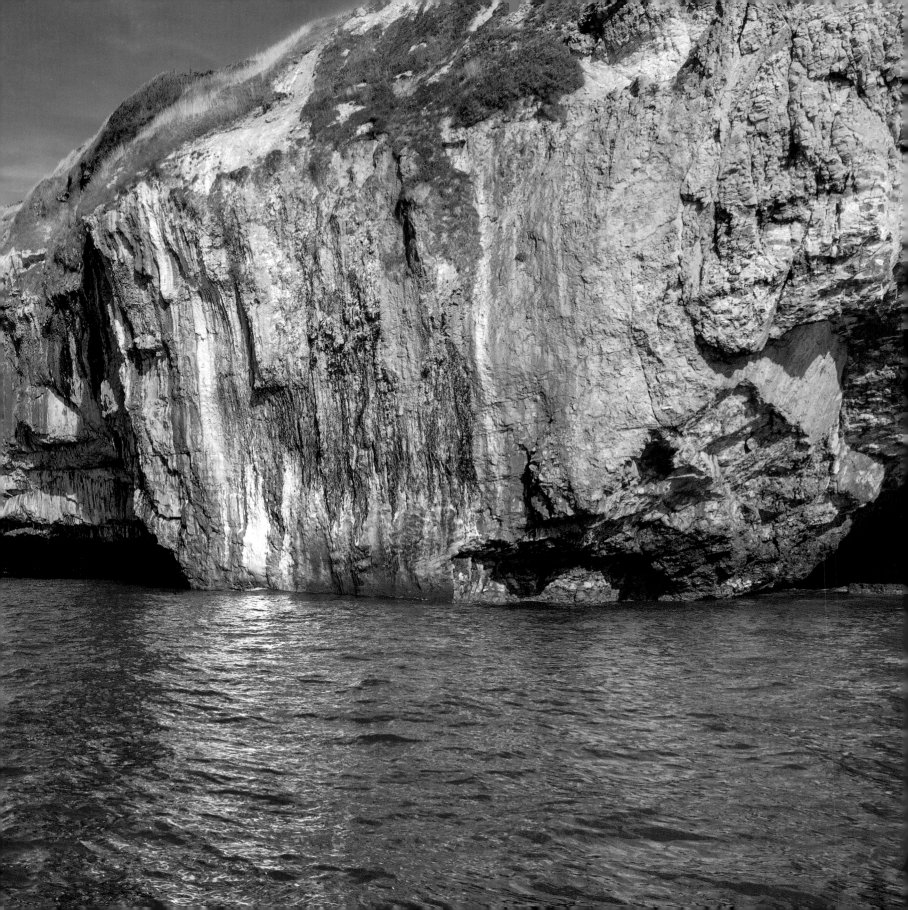

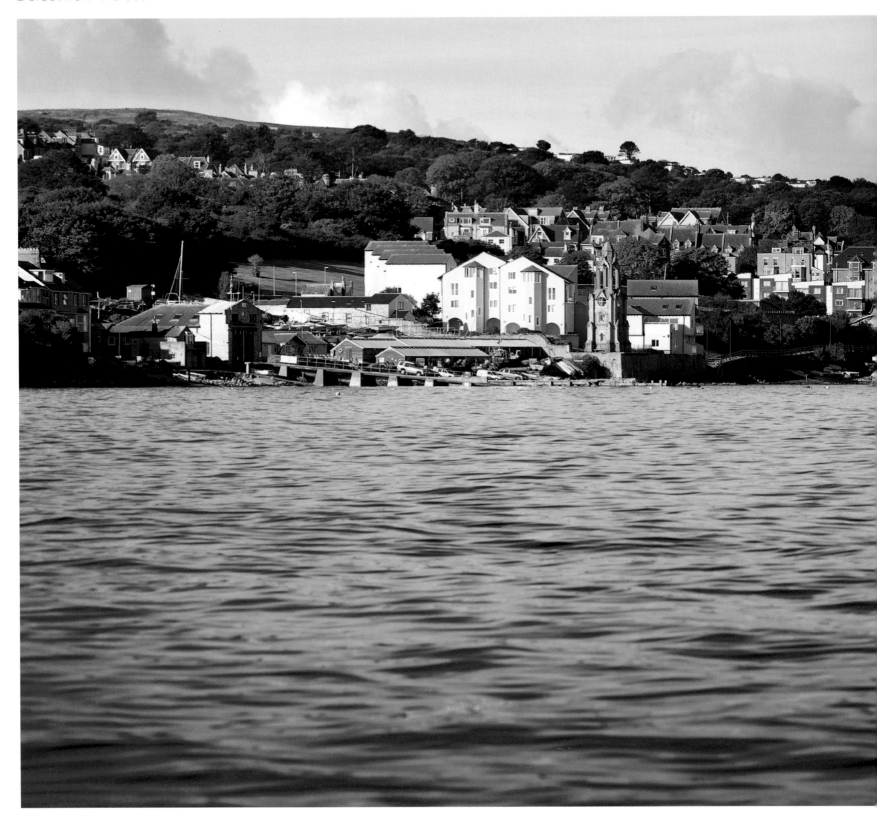

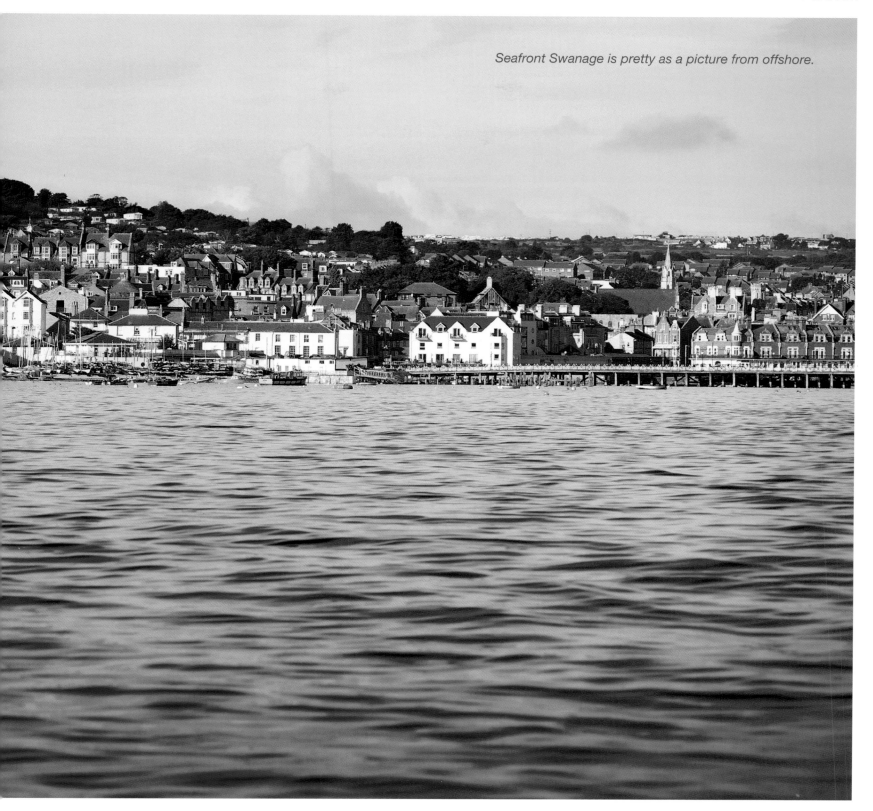

Seafront Swanage is pretty as a picture from offshore.

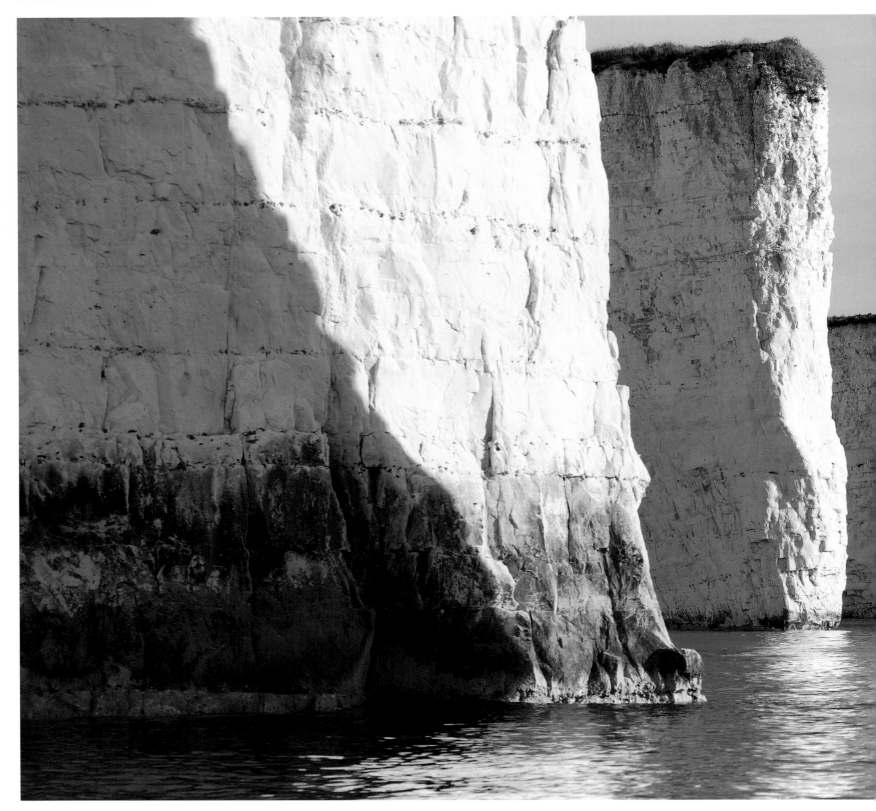

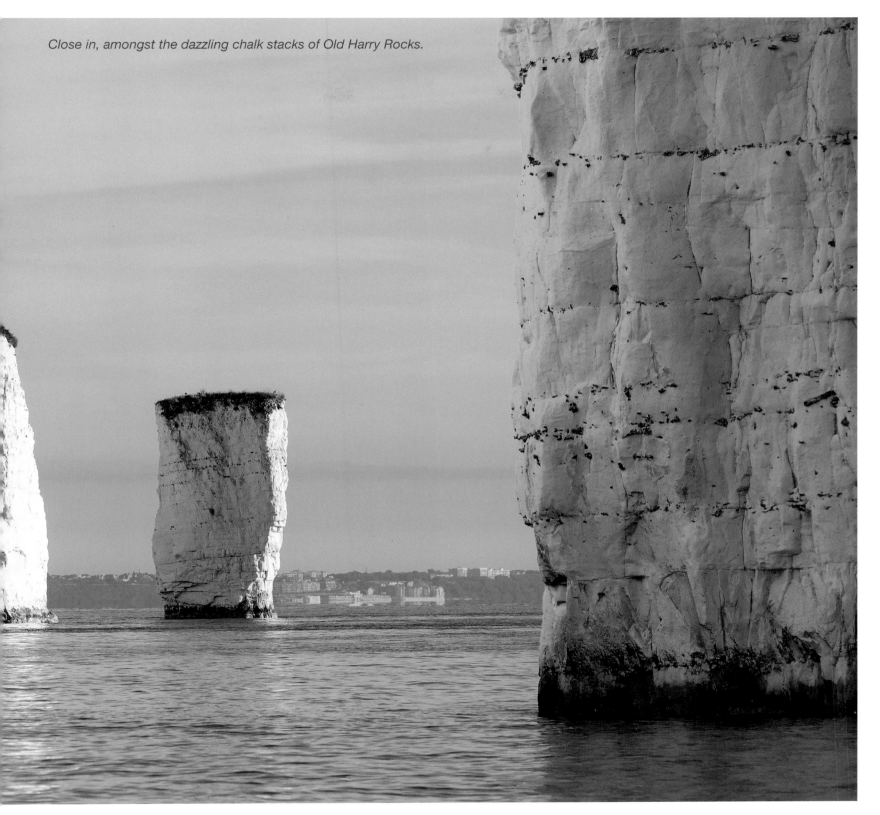

Close in, amongst the dazzling chalk stacks of Old Harry Rocks.

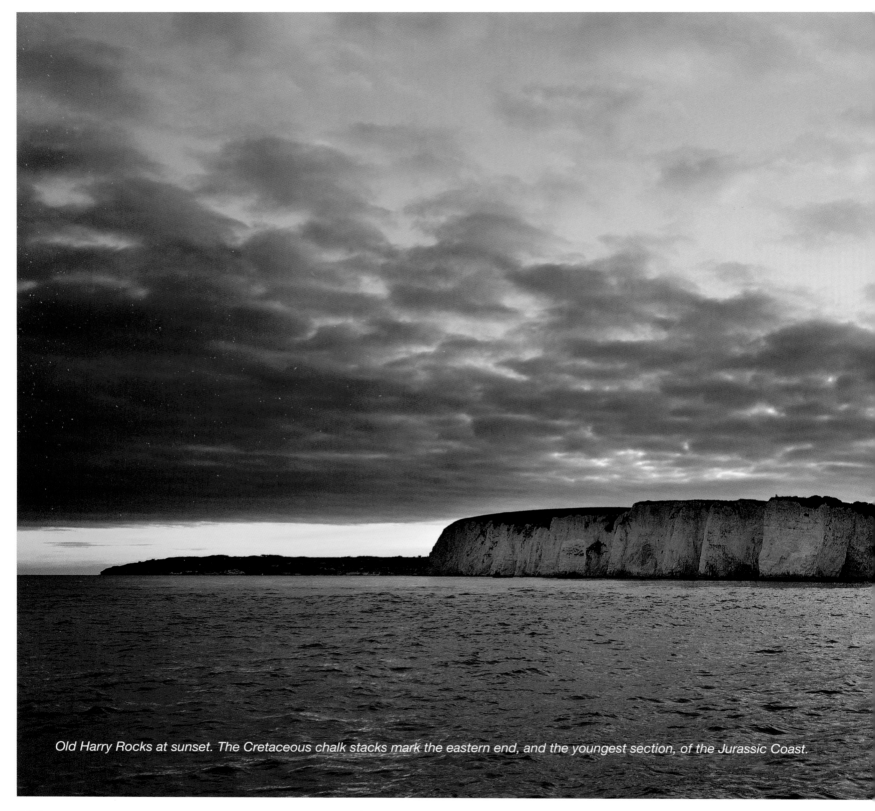

Old Harry Rocks at sunset. The Cretaceous chalk stacks mark the eastern end, and the youngest section, of the Jurassic Coast.

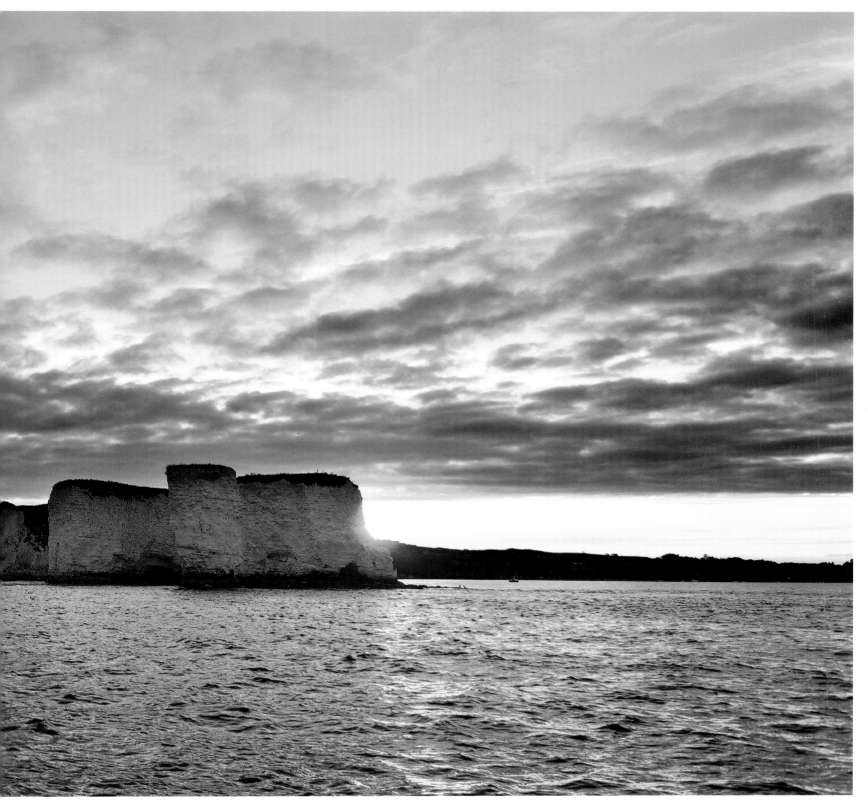

THE
JURASSIC COAST

FROM THE SEA

THE LARGEST
SELECTION OF IMAGES

JURASSICPHOTOGRAPHIC.COM

Whether you prefer vintage models, or the latest sports cars, you'll find 200 ideas for places to see and events you can take part in inside this unique guide to France. Covering everything automotive, from museums and concours d'élégance, to motorsport events and track days, this book is packed with useful information and essential data.

ISBN: 978-1-845847-42-5
Paperback • 21x14.8cm • £14.99 UK/$24.95* USA • 248 pages • 503 pictures*

For more info on Veloce titles, visit our website at www.veloce.co.uk • email: info@veloce.co.uk
• Tel: +44(0)1305 260068
** prices subject to change, p&p extra*

Dogs on wheels
Travelling with your
canine companion

Norm Mort

**The Efficient
Driver's Handbook**
Your guide to fuel
efficient driving
techniques and car
choice

Dave Moss

**First aid for
your car**
Your expert guide to
common problems
& how to fix them

Carl Collins

**The Essential
Driver's Handbook**
What to do in the event of an
accident, roadside first-aid, safety
tips for lone drivers & much more

Dealing with a breakdown

First-aid

Motorway accidents

Lone female drivers

Legalities

Fire fighting advice

Bruce Grant-Braham

With around 7 million members, and a 113-year history, the RAC organisation is regarded as THE expert on motoring. Veloce is proud to be the RAC's publishing partner and of the range of inexpensive, informative and, often, money-saving books we are rolling out as quickly as possible to aid motorists, motorcyclists and cyclists. Visit our website – www.veloce.co.uk – to see the full range of books in this series!

Index

DORSET

Overcombe

Osmington Mills

Ringstead Bay

White Nothe

Bat's Head

Durdle Door

Lulworth C

Weymouth

Chiswell

Portland Bill